Celtic Calligraphy

Calligraphy, Knotw[...] [...]ation

Kerry Richardson

lá Fhéile Pádraig

St. Patrick's day

Dedication

*Dedicated to Peter Westmoreland, my best friend and better half;
to my son, Khyle Westmoreland; and to the extra, extra special
person – she who shall remain nameless!*

*Also to Russell and Tina Saxton; Mamma and Grandpa
Westmoreland; my dad, Alan Edward Richardson; my sister
Moira Tuckwood; my best friend, Jo Pearson; and Keith and
Angie White, lifelong friends and godparents to my children.*

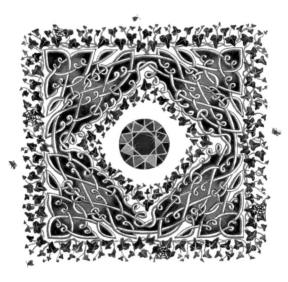

Celtic Calligraphy

Calligraphy, Knotwork and Illumination

Kerry Richardson

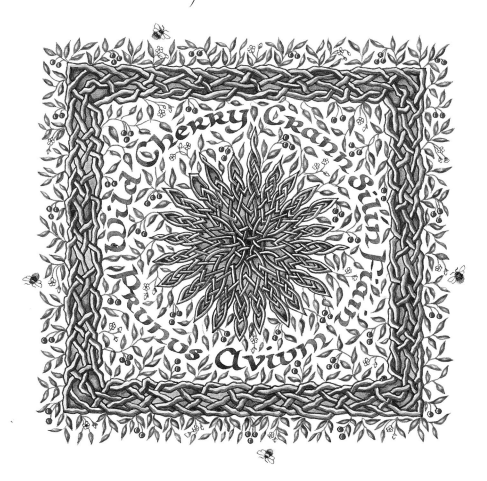

Gill & Macmillan

Published in Ireland in 2014 by
Gill & Macmillan
Hume Avenue, Park West, Dublin 12
with associated companies throughout the world
www.gillmacmillanbooks.ie

Text copyright © Kerry Richardson, 2014

Photographs by Paul Bricknell at
Search Press Studios, except for page 9, used by
permission of the Chapter of Lichfield Cathedral.

Photographs and design copyright ©
Search Press Ltd, 2014

ISBN: 978-0-71715-727-3

Suppliers
If you have any difficulty obtaining any of the
materials and equipment mentioned in this book,
please visit the Search Press website:
www.searchpress.com

Publishers' notes
All the step-by-step photographs in this
book feature the author, Kerry Richardson,
demonstrating calligraphy techniques. No models
have been used.

Acknowledgements

*This book could not have been written without the generous
help of Russell Saxton, who has tirelessly helped me with the
wording of this book. He's a superhero, wordsmith
and treasure. My thanks also to Tina Saxton; the superb
omniglot man Simon Ager for his Celtic translations; the whole
amazing team at Search Press and especially my brilliant editor
Edward Ralph; Roz Dace; Martin de la Bédoyère;
and Paul Bricknell for the marvellous photography.*

*Also to Lichfield Cathedral for their kind permission to
allow me to use their images from The Saint Chad Gospel;
Clare Townsend, the wonderful Libraries' Manager that has
helped me so much; photographer and journalist Peter Jordan;
Len Smith, who hand-carved the beautiful eagle walking stick
on page 79.*

*To all the teachers that have inspired me, both from school:
Mr Sellick, Mr Smith, Miss McCormack, Mrs Brown;
and from college: Mr Smith and Mrs Derby.*

*To Elaine Marren, Gerry Molumby and the
Nottingham St Patrick's Day committee; Trevor and
Sandra Miles from Pen People UK; Canadian Allison from
Derwent; John Bell; Liz, Pat and Chas Wood; Angi and
Rob Jackson; Mrs Storer; Mrs Martin; Liz Weston MBE;
Carla and Andrew Tucker; Clare Pope;
the Reverend Green; Bill Foster.*

And far, far too many others to mention.

Page 1
Saint Patrick and the Snakes

*A zoomorphic knotwork design incorporating a blessing
in Celtic calligraphy written in both Irish Gaelic and
English. The elements are brought together with snake
heads and shamrock embellishments to honour and pay
tribute to the Saint Patrick's Day celebrations.*

Page 2
Emerald and Ivy

*Ivy leaves entwine around a central gem in this work.
Green oak tortrix moths and spiders' webs are effective
embellishments that echo the colour scheme.*

Page 3
Wild Cherry

*The wild cherry provides inspiration for this twisted
knotwork design, and the name is picked out in Celtic
calligraphy in Latin, Irish Gaelic and English. Fruit,
leaves, flowers and the red-tailed bumblebee have been
used as embellishments here.*

Opposite
Shamrocks

*Created for a Saint Patrick's Day card, this design
brings the shamrocks and the knotwork design together.
I enjoyed adding a four-leaved clover to the mixture to
hopefully bring an extra touch of luck!*

Printed in China

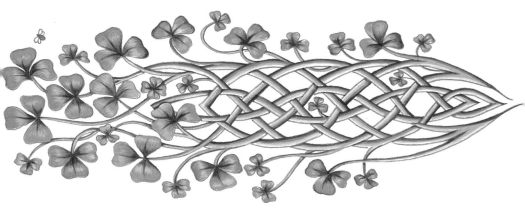

CONTENTS

INTRODUCTION

This book will introduce you to the world of Celtic calligraphy, knotwork designs and illumination. This is a fascinating world of beautiful and intricate designs, one that I have been exploring for more than twenty years. It has been a voyage of discovery, love and enthusiasm.

Although the dense knotwork and lettering may look complicated at first glance, it is quite easy to do if you know how. This book invites you to join me on my journey, and will help you to achieve the intricate overlaps and distinctive forms of the letters through simple step-by-step instructions.

Celtic calligraphy has a multitude of uses, from the purely decorative to the practical. You can use it in creating original artwork, personalised greeting cards, stationery and many other forms of artistic expression. Although the origins of the art are rooted in the ancient world, its mystical and often ethereal beauty also sits well in our modern lives.

All aspects of the Celtic calligraphic art form are covered through the demonstration of techniques that will allow you to achieve stunning results. My hope is that you will go on to develop your own personal interpretation of the art and pass it down to a new generation, so that this wonderful and ancient art can live on.

I hope that you will find the contents of this book interesting, the instructions easy to understand, and the end results rewarding. I hope that you become as passionate about this art form as I am myself, and that you will be inspired to create your own projects. I would forewarn the reader that Celtic calligraphy and knotwork can take over your life – but rest assured that it will take over in a very pleasant and enjoyable way!

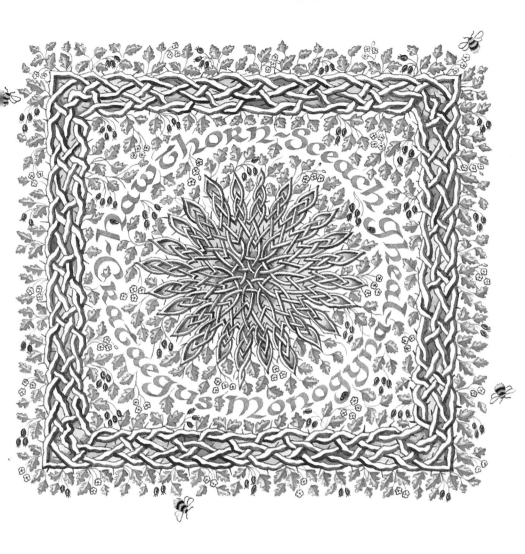

Hawthorn

The hawthorn, also known as the fairy tree or May tree, is an example which brings together the art of Celtic calligraphy with knotwork and embellishments of flowers, fruit, leaves and insects associated with the tree.

This piece, like the Wild Cherry *on page 3, is taken from a collection of 'birth trees' I developed. Based upon trees native to historical Celtic areas, each piece represents one species of tree for each month of the year. In the collection, knotworks of entwined branches border a central motif of the appropriate tree, which is then surrounded with calligraphy that gives the tree's name in English, Latin and Irish Gaelic.*

THE HISTORY OF CELTIC CALLIGRAPHY

The art of writing as a form of communication goes back as far as the first cave paintings. As humans have developed, art and language have flourished. Early images like those left by Neolithic peoples gradually developed into sophisticated systems of 'picture words', such as the hieroglyphics of the Ancient Egyptians, developed around 3500BC.

The Phoenicians are acknowledged to have been the civilisation who invented the first letter-based alphabet around 1000BC, replacing picture-words with more abstract shapes that represented sounds. This development marked the beginning of the process that would lead to the writing with which we are familiar today.

The Romans conquered most of the Western world and exported their writing and teaching styles to the whole of their domain. Their scribes typically used styles known as 'uncial' and 'half uncial', which were used from the fourth to the eighth centuries. The phrase 'Celtic calligraphy' typically refers to the style of writing known as 'insular majuscule', which was developed from these earlier scripts by early Christian monks in Ireland. It spread across Europe and was used from the seventh century until as late as the nineteenth century.

Insular majuscule remained in common use across much of Europe until as late as the nineteenth century, and is still popular today because of the beauty of its letterforms. The style is associated with some of the most beautiful examples of calligraphy in existence, including the *Book of Durrow* and the *Book of Kells*. The original copies of both of these books can be found in Dublin's Trinity College, Ireland.

The *Book of Kells* is regarded as one of the greatest treasures in the world, not just because of the calligraphy but because of its beautiful artwork and illuminated design. It was written in approximately 800AD and is attributed to Saint Columba, also known as Colum Cille, who founded a monastery in Iona, an island off the west coast of Scotland. After the monks fled Iona in 806AD due to Viking raids, they moved to a new monastery in Kells, County Meath, Ireland. The manuscript contains the four gospels of the Bible written in Latin on vellum. At least three different scribes are thought to have contributed to it.

Other notable works that use a similar style of calligraphy and illumination include the *Book of Chad* (pictured opposite), the Lindesfarne Gospels, the Saint Gall Gospel and the *Book of Deer*. In this book, you will find interpretations of the lettering and illuminated knotwork designs inspired by those in the *Book of Kells* and other historical documents; and will see how the calligraphy has been adapted for use today.

[Illuminated manuscript page with Celtic calligraphy and marginal notes in insular script]

The Book of Chad

These examples of Celtic calligraphy and decoration are taken from the Lichfield Gospels, also known as the Book of Chad.

On the calligraphy page (main image) there is a hand-written section in the margins of what is widely regarded as the earliest example of the Welsh language on the written page.

Part of the knotwork design on the carpet page – a typical feature of insular illumination – has been left unfinished (see inset), showing how the knotwork was inked in before being coloured.

The original Book of Chad *can be found and seen at Lichfield Cathedral in Staffordshire, UK. Images used by permission of the chapter of Lichfield Cathedral.*

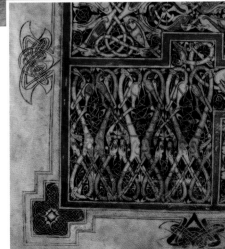

MATERIALS

WRITING MATERIALS

PENS

You can use any pen with a chisel-shape nib you like for the calligraphy in this book. Dip pens, traditional fountain pens or felt-tip pens are all suitable. My current favourites are ZIG calligraphy pens because the nibs are strong, the ink is waterproof and archival quality, and they are available in a good range of colours including pure black and metallics. Look for these qualities in the pens you choose.

When using a dip or fountain pen, I prefer to use Daler Rowney's acrylic artists' inks as they are permanent and waterproof. Permanent coloured inks for fountain pens are also available in convenient cartridges.

I also use fineliners, such as those from Uni Pin, for flourishes and detailed work, but any make of draughtsman/drawing pens or fineliners will do. The most useful sizes are 0.05mm (¹⁄₆₄in) and 0.1mm (¹⁄₃₂in), but sizes up to 0.8mm (¼in) are useful. I particularly love Pilot's extra fine silver and gold marker pens for adding extra touches of illumination, as they are clean and easy to use.

PAINTS AND PAINTBRUSHES

You can also use paintbrushes for Celtic calligraphy, knotwork and illumination, as the original scribes used to. In the book I have used fine size 0, 00 and 000 round brushes. I use any make so long as they have a nice fine point. For larger pieces obviously you will need bigger sizes.

Like inks, you can use almost any paint for Celtic calligraphy and decoration, including poster paints, watercolours or even household paint for particularly large motifs! I tend to use Daler Rowney's System 3 original and/or heavy body acrylic range paints.

You can achieve beautiful metallic effects by mixing gold powder with gloss acrylic glaze medium. I have used Schmincke brand, but any other brand will do.

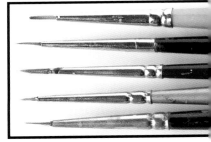

To the right are a selection of the fine paintbrushes I use. Ensure all of your writing brushes keep a good point, but keep hold of older frayed brushes for mixing paint.

Shown on these pages are a variety of pens, including dip pens made from feathers, bamboo or tubes of dowelling. Also shown are metallic markers, fountain pens, replacement nibs and cartridges and a selection of inks and paints.

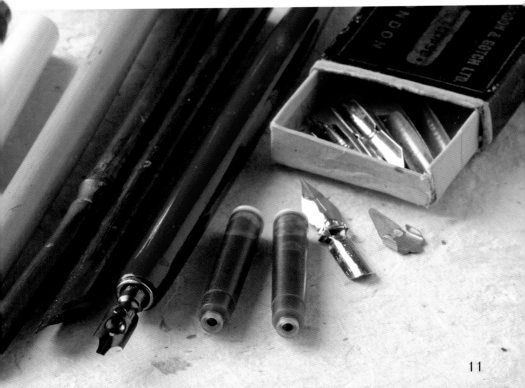

PENCILS AND PENCIL CRAYONS

An HB pencil is the number one tool for measuring up
knotwork patterns and embellishments, and it is also used
for adding temporary ruling lines. You can also rub these out
using an eraser once you have completed your pen work.

If you are not confident in using paints or inks with a
paintbrush you can use pencil crayons to colour your work.
Derwent's inktense range of coloured pencils are brilliant,
as are their watercolour and coloursoft ranges, but there are
other brands that are equally good.

*An HB pencil, pencil crayons
in various colours, and smooth
watercolour paper.*

PAPER

You need a smooth surface for your calligraphy so
that the pens will not snag and spatter on the page.
You also need a thick enough surface to be able to take the
absorption of the inks and paints. My favourite paper is
bamboo 265gsm (100lb) paper from Hahnemuhle as it
is pre-stretched and smooth. Any other smooth, thick,
heavy cartridge paper or card will do.

You can use vellum or other paper substitutes,
but for the book projects I have used 220g (135lb)
heavyweight paper from Daler Rowney.

TIP
*I always use daylight, but you might like
to use an artificial lamp to help you as you
work. If so, try to buy a daylight bulb.*

OTHER MATERIALS

Scrap paper I use a lot of scrap paper to practise with for the measurements, calligraphy and rough designs. Any paper will do. I use a lot of very cheap note pads and reams of copy paper.

Putty eraser Erasers are an essential piece of kit to remove ruling lines, tidy up sketches and – of course – hide any evidence of mistakes you make in your sketches! A soft putty eraser is the best thing you can use to remove pencil marks.

Pencil sharpener A fine point on your pencil will help you with your accuracy.

Ruler A ruler is essential for creating straight lines and ensuring the correct proportions for your calligraphy.

Compass A pair of compasses is a useful tool for creating accurate curved lines, which can help when working round corners on your calligraphy and knotwork.

Palette I tend to use a plate to mix my paints and inks on, but whatever palette shape or size which you feel happy with will do.

Scrap paper, putty eraser, a pair of compasses, steel ruler, pencil sharpener and a porcelain plate to use as a palette.

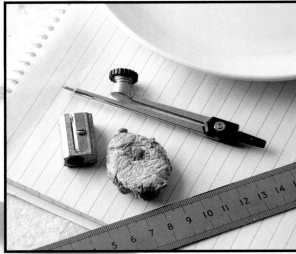

BASIC TECHNIQUES

The following pages explain a few basic techniques for using your pen correctly and ruling lines on your paper, ready for you to write your Celtic calligraphy.

HOLDING THE PEN

Calligraphy pens have a chisel-shaped nib, with a thick side and a thin side (see right). This characteristic means that they can produce a variety of different lines and effects, which is important to producing the distinctive shapes of Celtic letterforms.

Perhaps most fundamental to producing the distinctive swelling lines of calligraphy is the way you hold the pen in order to make use of the shape of the nib.

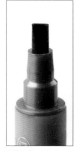

Thick side. *Thin side.*

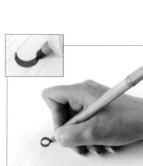

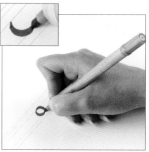

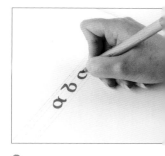

1 Hold the pen on the barrel, close to the nib as shown. Use a fairly tight grip so that the pen is firmly under control, but not so tightly that you shake. Keep your forearm on the table surface.

2 Make sure that the nib of the pen is at an angle of roughly 45 degrees to your guidelines, as shown. Keep your forearm in place as you work each letter, and move your hand to make the shape of the letter.

3 As you finish a letter, move your whole arm so that you begin the next letter from the same angle.

LINES AND ZIG-ZAG

The chisel nib is what gives the curved letters of Celtic calligraphy their shape. This will show you how to achieve lines of uniform thickness.

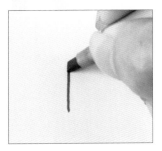

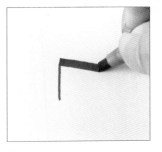

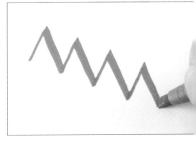

1 Drawing the thin part of the nib across the paper gives a fine line as shown.

2 As you work, do not let the angle of the nib change. This way, as you change the direction of the stroke, the thicker part of the nib will give a broader line.

You can practise this angled movement by creating zig-zags. Although simple, this movement will give you valuable experience in holding the nib steady while using the pen.

SNAKE

Drawing curves while holding the nib steady will result in a smooth curve that gradually becomes thicker or thinner, creating the beautiful script.

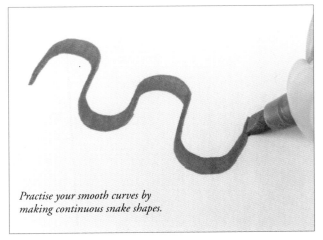

1 As before, hold the pen firmly so that the angle of the nib can not change, and draw a curve.

Practise your smooth curves by making continuous snake shapes.

15

PROPORTIONS FOR CELTIC CALLIGRAPHY

The calligraphy used in the *Book of Kells* uses proportions of 1:2:5:2.
These proportions give the letters their shape. This is explained in the
illustration below.

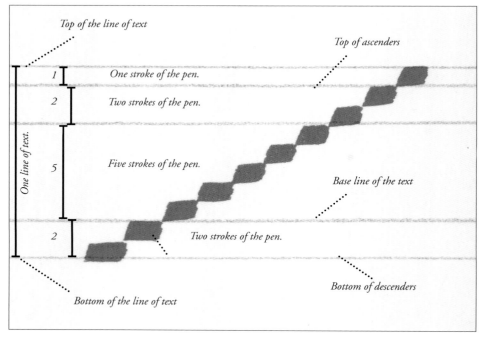

*Each line of text is split into four smaller parts, as shown here. Using
the width of the thick side of the nib as one measure, you can work out
the 1:2:5:2 ratio by drawing ten short abutting lines as shown here.
This is explained further on the opposite page.*

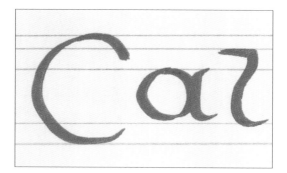

*Different letters use different amounts of
space. The capital 'C' uses all of the space
from the top to the bottom of the line, while
the 'a' uses only the five-stroke central area.
The 'l' sits on the base line, but the top
of it (the ascender) reaches the top of the
ascenders line.*

*The space each letter uses on the line is
demonstrated on pages 22–29.*

RULING UP FOR YOUR LINES OF TEXT

Working out the size of pen nib you will use for your phrase will allow you to calculate the size of the lines you will need. In this example, I am using a 2mm (¹⁄₁₆in) nib. Following the proportions of 1:2:5:2, I need to rule guidelines of 2, 4, 10 and 4mm (¹⁄₁₆, ⅛, ⅜ and ⅛in) for each line of text. This gives an overall height of 20mm (¾in) for each line of text.

These instructions show how to prepare guidelines for a single line of text relatively quickly. Ruling up multiple lines of text with the correct spacing between them is explained overleaf.

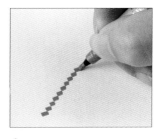

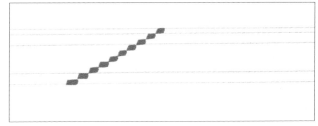

1 Use the thick part of the pen to make a 'staircase' of ten short strokes. Each stroke should be slightly offset from the previous one, and touch at the corners as shown.

2 Using a ruler and an HB pencil, carefully draw faint parallel guidelines above the topmost and under the bottommost stroke, then under the topmost stroke and the strokes two below that, five below that and two below that. This creates ruling guidelines that have the correct proportions for the letters of your Celtic calligraphy. Carefully measure and copy the distances between the lines when ruling up the guidelines for your artwork.

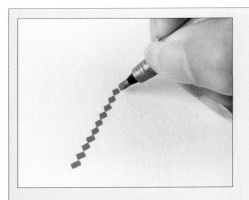

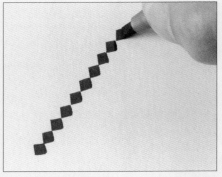

The advantage of using the fat side of the pen to work out the proportions and size of each line of text is that your calligraphy will fit neatly into the line, whatever the size of nib you use. The left image shows a 2mm (¹⁄₁₆in) nib being used, and the right a 3.5mm (³⁄₃₂in) nib.

SPACING YOUR LINES OF TEXT

In order to make the most of your calligraphy, knotwork and decoration, it is important to ensure that each part is placed in the best spot on your work. I encourage you to experiment with the layout on rough paper before beginning any calligraphy.

To follow the style of the *Book of Kells*, each line of text needs to be separated from the one above by half its height. This is equal to the thickest part of the 1:2:5:2 proportions, so if using a 2mm (¹⁄₁₆in) nib, I need to leave a 10mm (³⁄₈in) gap between lines. In total, this means two lines of text with the correct spacing will measure 50mm (2in) in total: 20mm (¾in) for each line, and 10mm (³⁄₈in) between them.

With this information, we can position the phrase in the best position on the paper.

TIP

The best position is often not quite central – leaving a little extra space at the bottom of your work helps to make the piece appear balanced.

1 Work out where you would like the text to sit by eye. I like the top of the text area to be closer to the top of the page than the bottom is from the bottom. Measuring down from the top of your paper, make a mark with your pencil 7cm (2¾in) from the top. This is the top of the text area.

2 Carefully make a set of marks 2, 4, 10 and 4mm (¹⁄₁₆, ⅛, ³⁄₈ and ⅛in) below the first mark, for your first line of text.

3 Leave a gap of 10mm (³⁄₈in) for the spacing between lines of text and make another mark here.

4 Make marks 2, 4, 10 and 4mm (¹⁄₁₆, ⅛, ⅜ and ⅛in) below this for the second line of text.

5 Move the ruler further along the paper, and make a second set of marks further along the page.

6 With these marks in place, you can use the ruler and pencil to join each set of marks with parallel ruling lines at the correct spacing.

GETTING YOUR TEXT CENTRAL

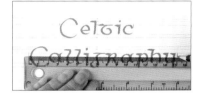
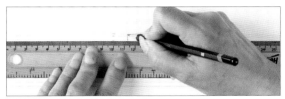

1 Write out your text on a rough piece of paper. Measure the length of each line of text – 7.5cm (3in) for the top line and 15cm (6in) for the bottom line in this example.

2 To place the first line centrally on your final paper, deduct the length of the text from the length of the paper, 30cm (11¾in) in this example, and make a note of the result: 22.5cm (9in). Divide the result in half and make a note of the new result: 11.25cm (4½in). Measure this distance in from the left, and make a mark in the first line. This is where the text will begin.

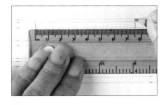

3 Measure a distance from the first mark, equal to the length of the line of text; in this example, 7.5cm (3in). This is where the text line will end. Mark this point with the pencil.

4 Repeat the process for the other lines. In this example, the bottom line of text is 15cm (6in) long. Deducted from 30cm (12in) and divided by two, the line will begin 7.5cm (3in) in from the left.

5 Go back and extend these marks so that they are the full height of the line of text. You are now ready to write out your calligraphy.

CALLIGRAPHY

The *Book of Kells* is written in a style known as insular majuscule, which is a development of the uncial and half-uncial styles used by Roman and Greek scribes. In contrast to earlier writing, which was restricted to angular strokes to mark rough surfaces like stone or papyrus, uncial script is written using bold, rounded and unjoined majuscule (capital) letters. The introduction of rounded strokes to make the letters was only made possible by the smoother writing surfaces like parchment and vellum (prepared calf-skin) then coming into common use.

Originally written using single bold strokes of the pen, uncial script had no separation between words, nor particular emphasis on accented syllables or letters. It evolved over the centuries to include more ornate letters using separation between words, accents on stressed letters, flourishes, and ascenders and descenders – that is, the parts of letters which rise above or fall below the mean line of the script, such as the tall stalk of an 'h' and the lower stalk of a 'p'.

Half uncial developed at the same time and is an almost entirely miniscule (lower case) script. It never rivalled uncial for use in religious texts, but the use of lower case letters in our modern alphabet can be traced directly to this style of script.

Taking elements from these earlier scripts and adding innovations and refinements that make it so wonderfully decorative, insular majuscule typically uses the same strokes to produce both capital letters and lower case letters, simply filling more of the space within the ruled lines for the larger capitals. The letters 'I' and 'J' are exceptions to this, as they lose their dots in each case, but even in these examples the capital remains very similar to the lower case form.

Close study of the ancient manuscripts has enabled me – after much trial and error – to produce a handmade bamboo pen which fits perfectly into the letterforms of the mediaeval scripts. This, is turn, has enabled me to work out the proportions and spacings that are needed, so that we can use them to create contemporary works of art that are as close as possible to the original letterforms used by the three different scribes who contributed to the *Book of Kells*. The following pages show you how to build the letters of the alphabet up penstroke by penstroke. Most will be immediately recognisable, but the forms for 'G' and 'D' are quite unusual to modern eyes.

I have also included examples and notes on capital letters, adding flourishes, and how to put the letters together in sentences. I almost always add decorative flourishes to my calligraphy as they give a more fanciful and decorative dimension to a finished piece of work, evocative of the original intention of making beautiful writing. I call this my 'Kerry Unkial' Celtic calligraphy style. Let's bring calligraphy into the twenty-first century!

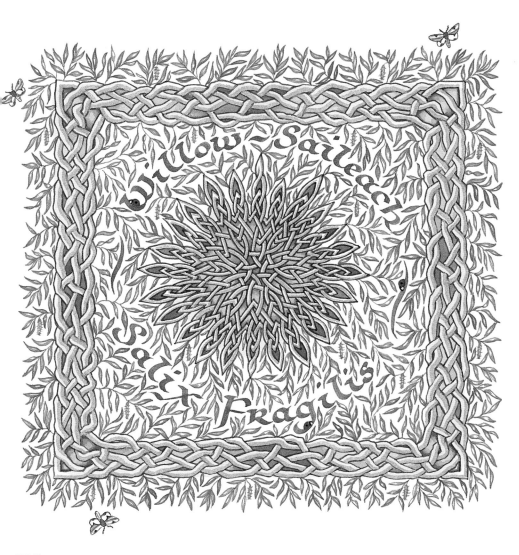

Willow

Another example from the birth tree collection, with the text in a calligraphic style inspired by various historical books. The picture itself has a circular knotwork in the centre as if looking down on a tree. The plaited border is made of five lines that interlace to form a hedgerow around the piece; a new knotwork design of my own creation that shows how traditional designs can be the inspiration for your own innovative ideas.

The embellishments used here are the leaves and the swallow prominent moth, whose caterpillars you will find munching happily away at the foliage.

THE LETTERFORMS

Now that you have learned how to hold your pen and have a feeling
for the thickness and thinness of the nib (see pages 14–15), you can
begin practising the alphabet. As with everything in life, practise makes
perfect, so let us start by turning scribbling into scribing.

Working from left to right for each letter, follow the simple numbered
instructions below to draw the pen in the direction of the arrows. These
will show you where to start and which direction to work in when
forming and constructing the letter shapes, as well as show you where
the strokes fit within your ruling guidelines. Let us begin!

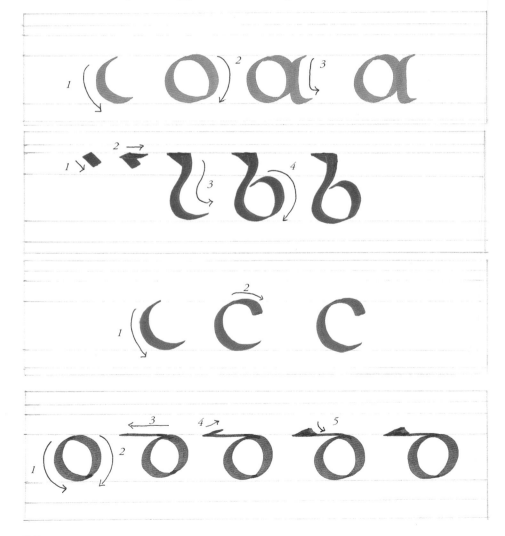

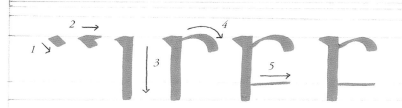

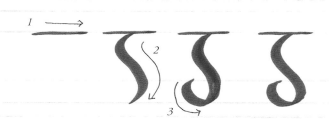

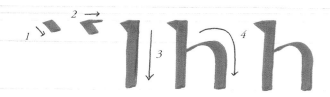

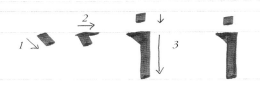

23

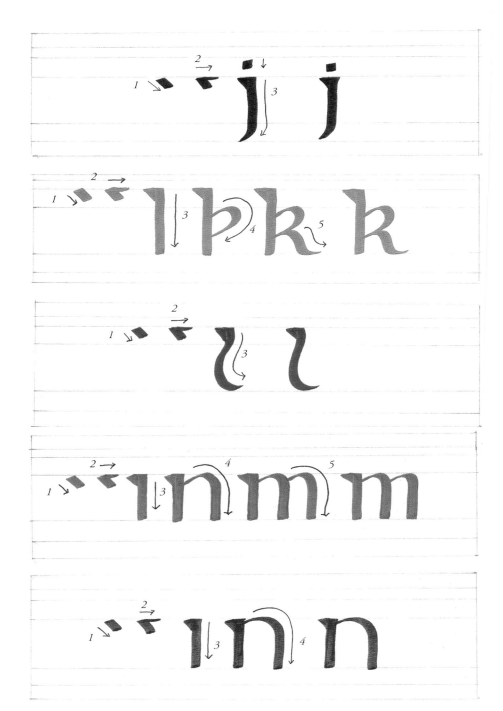

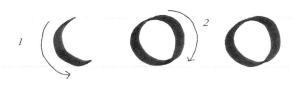

25

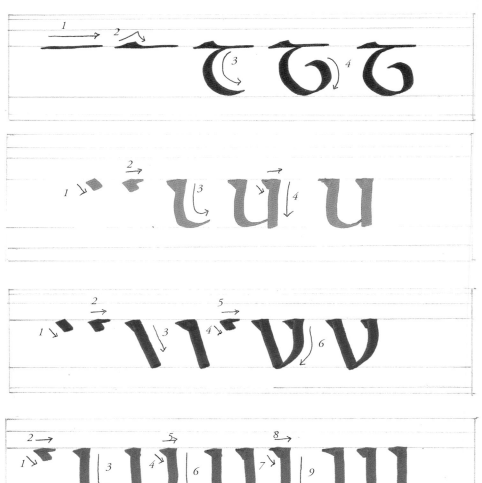

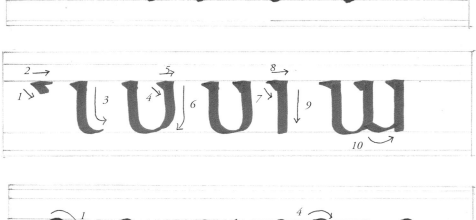

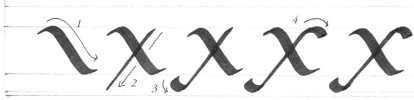

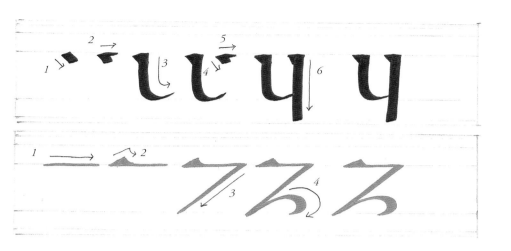

Birch

Once you are comfortable with producing the Celtic calligraphic script shown here, you should feel free to experiment with the letterforms. The birch tree piece shown here uses a mix of traditional letterforms alongside more modern ones such as the 'd'. I used the modern-day form here for clarity and readability, as well as to give the piece a contemporary feeling – like the birch itself, the mix provides a link between the ancient and modern worlds.

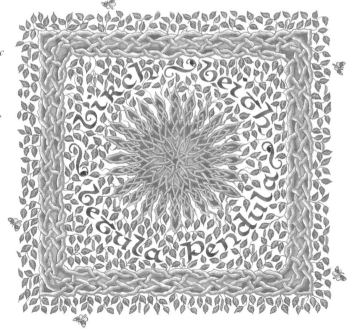

CAPITAL LETTERS AND VARIATIONS

As mentioned earlier, insular majuscule script uses the same letterforms for both capital and lower case letters. For modern calligraphers, who wish to add emphasis to a letter, you can create a larger form of the letter to mark a capital.

The examples on these pages show the space used for capitalised forms of each letter, along with examples of the letters with serifs (a small line on the end of a stroke), curlicues and other decorative flourishes added. These can be added to your own work as you wish. For each letter, I have placed the lower case letters next to the capitals so you can see how they look and fit together on the page.

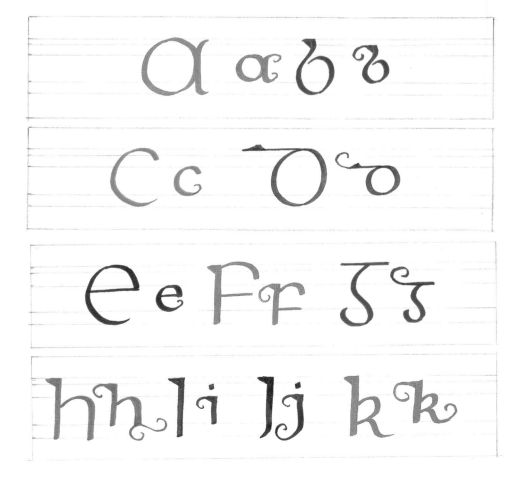

Ll Mm Nn

Oo Pp Qq

Rr Ss Tt

Uu Vv Ww

Xx Yy Zz

PUTTING LETTERS TOGETHER

When spacing words in a sentence I usually leave a gap of a letter's width in between each one, which I measure by eye just as you would when doing normal handwriting. The short sentences below, that I have chosen to illustrate this spacing, are made using the six Celtic languages. When translated, they all mean 'good luck', a sentiment which I truly hope will bring the very same to you.

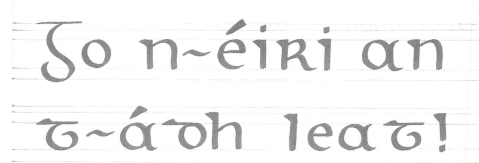

Go n-éiri an t-ádh leat! – 'Good luck!' in Gaeilge (Irish Gaelic).

Sealbh math dhuibh! – 'Good luck!' in Gaidhlig (Scottish Gaelic).

Pob Lwc!

Pob Lwc – 'Good luck' in Cymraeg (Welsh).

Aigh vie!

Aigh vie! – 'Good luck!' in Gaelg (Manx).

Chons da!

Chons da! – 'Good luck!' in Kernewek (Cornish).

Chãns vat!

Chãns vat! – 'Good luck!' in Brezhoned (Breton).

ILLUMINATING YOUR CALLIGRAPHY

ILLUMINATION

Illumination in calligraphy is literally the 'lighting up' of the text with decorated borders, initials and small illustrations. Historically, this was principally used for the decoration of religious manuscripts: the earliest examples of illuminated script date back as far as the fourth century AD, though the majority come from the Middle Ages. Some of the best-known Celtic examples include the *Book of Deer* from Scotland and the *Book of Kells* from Ireland.

In the most strict definition of the term, an illuminated manuscript refers only to manuscripts decorated with gold and silver, but in both common usage and modern scholarship, the term is now used to refer to any decorated or illustrated manuscript from the Western traditions.

Usually, mediaeval manuscripts were done on parchment but from the late Middle Ages began to be done on paper. At this time the few books that were produced were hand-drawn works of art and limited to the wealthy, but with the development of printing techniques and commercial publication of books, the technique fell into disuse as far as books were concerned.

Wealthy people would often commission artists (usually craftsmen or monks) to produce illuminated manuscripts as a status symbol, as these works were costly and time consuming to produce and only the wealthy could afford them. Often they would ask to have an image of themselves included as part of the illumination.

Today, the illuminated manuscript is still used for special occasions and one-off works of art such as personalised birth certificates, examination certificates, and family crests. They still look as beautiful and impressive as ever. In this section I will look at the various styles of illumination and explain the techniques used to produce them.

CELTIC KNOTWORK

Celtic knotwork is amongst the most recognisable style of European artwork from the mediaeval era. It is a style of decoration used widely in Celtic art and was used to decorate religious manuscripts as well as stone Celtic crosses and slabs. Its origins go back at least as far as the third century AD, with some examples in Roman floor mosaics.

The Celtic knot is sometimes referred to as the 'endless knot', or 'mystic knot'. The design alludes to the timeless nature of the human spirit and the endless cycle of birth and rebirth. The endless nature of

Celtic knots can represent an uninterrupted life cycle, and symbolically wards off disease and setbacks that interfere with our life's journey; they are a good luck charm.

Celtic art that pre-dates the beginning of Christian influence (circa 450AD) often includes step, spiral and key designs. These patterns found their way into the earliest Christian manuscripts. The earliest surviving example of true Celtic knotwork, dating to the seventh century AD, survives in the library of Durham Cathedral.

This chapter shows the techniques needed to create knotwork patterns that can be used to decorate our calligraphy, illuminated initials and pictures as borders around the page.

Celtic Cross

Muiredach's High Cross is the inspiration for this design. I have chosen and intertwined four knotwork designs from the Book of Kells *to decorate the piece, and chose Irish wildflowers and insects to embellish it in order to give honour to the master craftsmen of yesteryear.*

The original cross dates from the ninth century AD and can be found in the monastic ruins at Monasterboice, County Louth in Ireland. It is said to be the most beautiful and finest example of Celtic stonework sculpture that can be found in Europe.

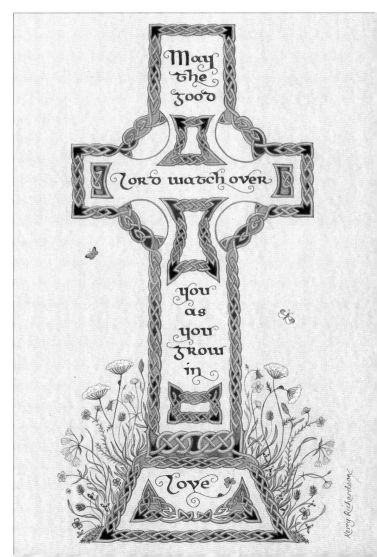

KNOTWORK

The cords in Celtic knotworks always alternate between going over and under one another. Always bear this in mind as you create your knotwork.

PLAITED LINES

This knotwork pattern is a plait interlacing, similar to many ancient designs used across the Celtic world on everything from page borders to grave markers. It consists of four separate lines which run continuously through the design.

TIP
I have used 1cm (⅜in) and 2cm (¾in) spaces when describing the measurements in this section of the book, but as long as the proportions remain the same (1:2), you can use any size you wish. For example, 2cm (¾in) and 4cm (1½in).

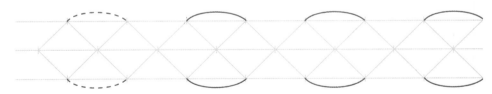

1 Using an HB pencil, draw three horizontal lines, each 1cm (⅜in) apart. This will give you a border for your knotwork to fit into. Next, make light marks every 2cm (¾in) on the top and bottom lines. Measure 1cm (⅜in) in from the left of the middle line and then make marks every 2cm (¾in) to create offset marks as shown. The final part of this stage is pencilling in the squares.

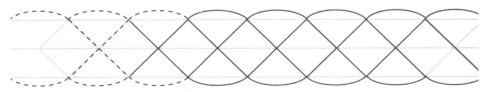

2 Draw freehand curves joining the marks above the top line, and below the bottom line, as shown.

3 Use the pencil to add additional curves to complete the basic template, then follow the lines through the central gaps, strengthening the squares.

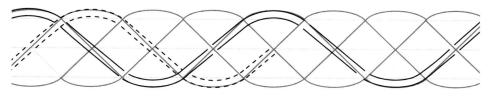

4 Thicken the fine pencil lines in turn (the diagram above has a dotted line in progress and one completed), and take the thickened 'cord' over the first fine pencil line you come to. As you come to the next line, the cord will need to go under, so leave a gap as shown. Carry on thickening the line, snaking it through the rest of the design, always remembering to go alternately over and under.

TIP

Imagine that the thick line is a train line going over and under bridges, and then you will soon be on your way!

5 Now that your knotwork is pencilled in, check that all the thickened cords look even and well-balanced. It usually takes me a while to rub out and re-draw the lines so that they look as good as they possibly can. Next, go over the pattern using a fine permanent drawing pen (see inset).

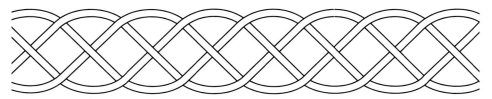

6 Rub out all your pencil lines to finish. You will now have a knotwork design to colour in.

FIGURES-OF-EIGHT

The figure-of-eight knotwork is another ancient design. Instead of being a continuous knotwork, this design consists of interlacing chain links of knotworks. Only two lines of the pattern weave their way through the whole length.

1 As for the plaited lines example (see page 34), use an HB pencil to draw three horizontal guidelines, each 1cm (⅜in) apart. Make light marks every 2cm (¾in) on each line, offsetting the marks on the middle line 1cm (⅜in) from the left-hand side. Pencil in the squares.

2 Use the pencil to draw freehand curves as shown, being sure to space them with a complete square between. These shapes form the basis for the figures-of-eight.

3 Put in an extra border line to connect the figures-of-eight shapes to each other. This completes your basic template.

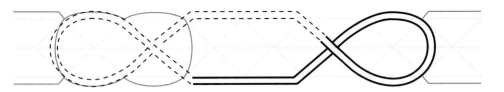

4 Thicken the fine pencil lines in turn as you extend them across the design (the diagram above has a dotted line in progress and one completed). Weave the lines over and under one another to create an enclosed chain link 'track' as shown.

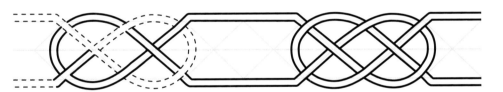

5 Thicken and extend the adjoining tracks in turn to build up the design, working over and under lines as you come to each one.

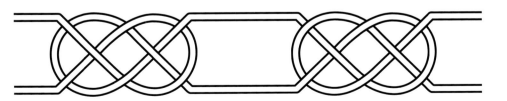

6 Tidy up and even out your work, then work over it with permanent pen. Allow to dry, then erase all of the pencil lines to finish.

WAVES

Again inspired by ancient work, this design consists of three
continuous lines that interlace with each other through the border.

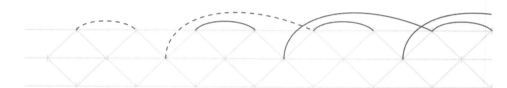

1 Draw three horizontal guidelines, each 1cm (⅜in) apart,
with the HB pencil. Make light marks every 2cm (¾in) on
each line, offsetting the marks on the middle line 1cm (⅜in)
from the left-hand side. Pencil in the squares.

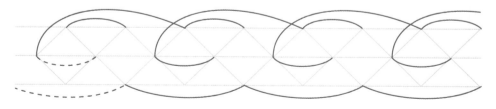

2 Using the pencil, draw small and large freehand curves
in turn as shown at the top of the border. The large curves
can overlap each other at this point.

3 Complete the basic design by drawing freehand curves
at the bottom and central part of the border. Pay careful
attention to the spacing.

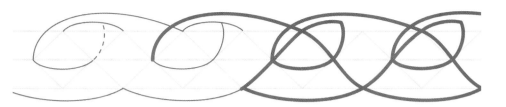

4 Add the vertical curves on the upper part of the border with the HB pencil, then use a darker pencil (a 1B, 2B or 3B are ideal) to pick out and highlight the wavy knotwork templates as shown on the right-hand side of the diagram.

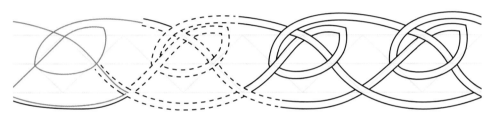

5 Thicken the fine pencil lines in turn as you extend them across the design (the diagram above has a dotted line in progress and those on the right-hand side completed). As always, weave the lines over and under one another in turn.

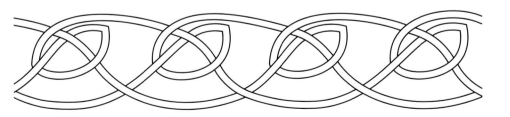

6 Tidy up the rough sketch, then go over the working carefully with a permanent pen. Once dry, erase your remaining pencil guidelines.

SEMICIRCLES

I call this design a semicircular knotwork because it consists of a lot of semicircles! Again, this is an old knotwork which is a continuous design. This one, however, has just the one interweaving line running all the way through it.

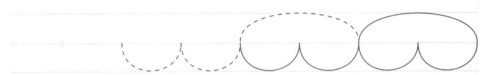

1 Use the HB pencil to draw three horizontal guidelines, each 1cm (⅜in) apart, then make light marks every 2cm (¾in) along the centre line. Add semicircular curves as shown between the middle and lower lines, joining every mark; then add the larger curves between the middle and upper lines as shown.

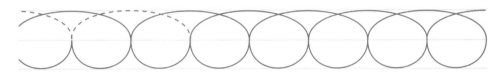

2 Still using the HB pencil, add a second set of overlapping curves between the middle and upper lines.

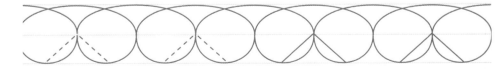

3 Draw angular straight lines inside the lower semicircles as shown to form triangle shapes along the bottom of the design.

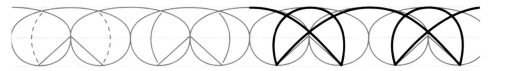

4 Add the final curves as shown on the left-hand side of the diagram. Next, using a darker pencil such as a 1B, 2B or 3B, pick out and define the basic pattern as shown on the right-hand side of the diagram.

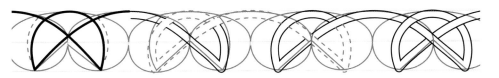

5 Thicken sections of the fine pencil lines in turn as you work across the design to help you work out where to take the cord over and under. The diagram shows one section in progress (the dotted line) and a completed section on the right-hand side.

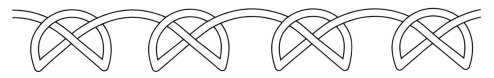

6 Finish off by tidying up with an HB pencil and eraser, then use a permanent pen to go over the completed design. Finally – and this is my favourite part of all – use an eraser to rub out the guidelines to reveal your completed design.

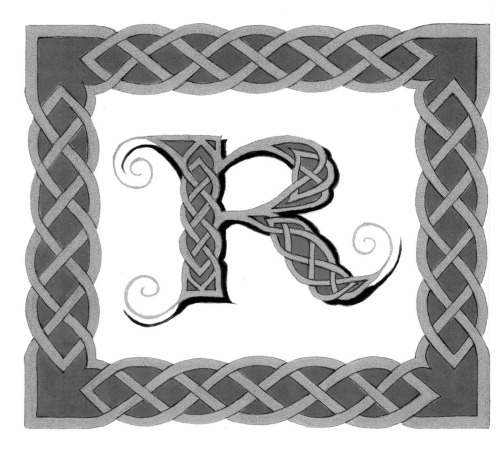

Illuminated R with plaited line knotwork border

The plaited knotwork border here is painted with emerald green ink and gold powder mixed with acrylic medium. I have used the same four line plaited design inside the letter with added flourishes and an aquamarine coloured shadow.

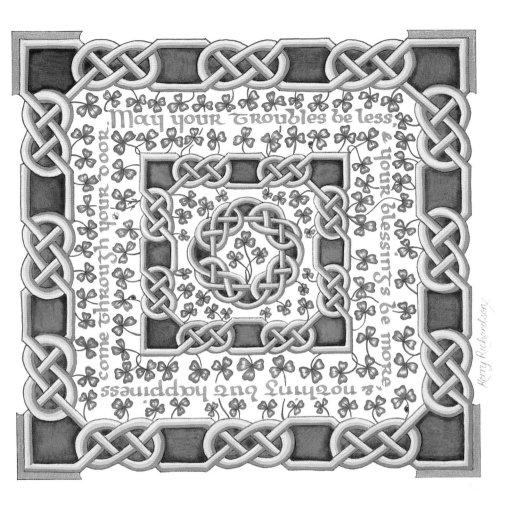

May your troubles be less, & your blessings be more, & nothing but happiness come through your door.

Kerry Richardson

An Irish Blessing

Greens and golds are the perfect colour scheme for this traditional Irish blessing, which sits as part of a concentric design made up of three figure-of-eight knotwork borders. Shamrocks, of course, are the perfect choice of embellishment – including a lucky four-leaved clover just to make absolutely sure that the blessing comes true!

Details from stage backdrop

This was a commission undertaken for Nottingham's Saint Patrick's Day celebrations, to be used as backdrops for the stage. The borders and motifs are a mixture of many different Celtic knotwork designs, including a wave pattern used for the borders.

The materials used were gloss household paint on plastic-covered hardboard. The colours are bright and simple, with a deep violet background in between the patterns.

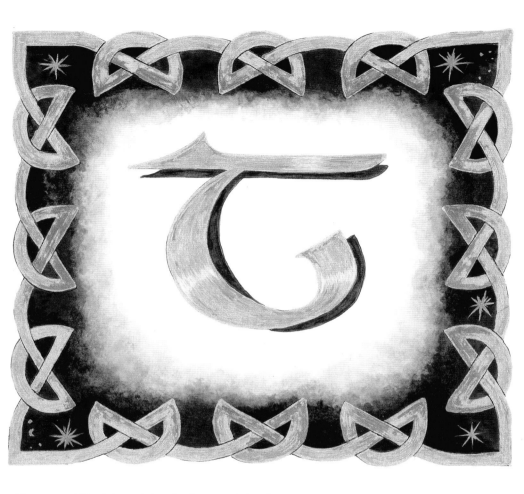

Illuminated T with semicircular knotwork border

*The semicircular knotwork has been used here to border the letter T.
Once the pencil lines were in place, I painted the blended sky effect
first. To achieve this I used small damp balls of cotton wool to gently
dab on ultramarine blue, deep violet and fluorescent pink paints. A
metallic silver pen was perfect to fill in the knotwork and the central
letter, as it was very easy to use and gives a highly polished and
shimmering look to the finished piece.*

KNOTWORK CORNERS

The corners on the following pages can be used in conjunction with the knotwork line on pages 34–41 to create a complete framed border. This can then be used to illuminate whatever centrepiece you wish to embellish, whether it be a single letter, a verse, a picture or anything else that you would like to create.

Each of the knotworks detailed on the following pages is begun in the same way: draw a 12 x 12cm (4¾ x 4¾in) square, a 10 x 10cm (4 x 4in) square inside that, and finally an inner 8 x 8cm (3⅛ x 3⅛in) square.

When following the instructions for the corner methods, the critical point is that the cords continue working over and under one another in turn from one side to another. For this reason, in each case the technique is shown in stages that work around the square examples. Start at the top left corner of each example and work round clockwise. The completed corner in each case is shown at the bottom left, which then extends into the final side to help clarify the method.

Illuminated A with four line plaited corners on a knotwork border

For this piece, I used the second, more complex method (opposite, bottom) to interweave all four lines of the plait together to join the two borders. I used pure cadmium scarlet and cadmium orange, while the yellow hue was made up of a mix of equal parts of fluorescent yellow and lemon yellow.

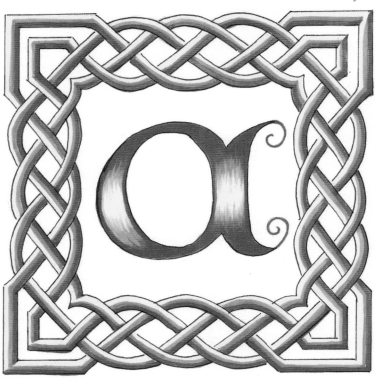

PLAITED CORNERS

METHOD ONE

This method takes two lines of the plait around the corner, creating a simple open effect.

1 Use an HB pencil to lightly mark the guidelines every 2cm (¾in) all the way round, offsetting the marks as shown, then join these marks as in stage 1 on page 34 to create a framework grid on which to work.

2 Fill in the first straight part using steps 1–3 of the plaited knotwork design (see page 34) to correspond with the example shown here. Next, extend the lines to the outside border corner and also the inside corner shape, as shown at the top right of the example. Repeat this process with the other three corners.

3 Thicken the lines as for the straight plaited knotwork (see page 35), taking the cord over and under in turn. Once completed, work around the rest of the design in the same way.

4 Finish off by tidying up your work, then use a pen to make the knotwork permanent. Once dry, erase all of the rough pencil lines.

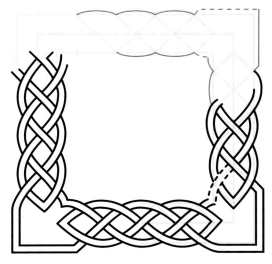

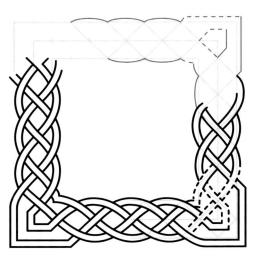

METHOD TWO

This method takes four lines of the plait around the corner, making a fancier, more intricate design.

1 Repeat stages 1 and 2 of method one (see above).

2 Add five extra lines to make a house shape in the corners, as shown at the top left here. You now have the four line continuous knotwork template.

3 Repeat stages 3 and 4 from method one to finish.

FIGURE-OF-EIGHT CORNERS

METHOD ONE

Constructing corners with a figure-of-eight knotwork is a simple task as there are only two lines to join together at the corners.

1 Use an HB pencil to lightly mark the guidelines every 2cm (¾in) all the way round, offsetting the marks as shown, then join these marks as in stage 1 on page 34 to create a framework grid on which to work.

2 Fill in the first straight part using steps 1–2 of the figures-of-eight knotwork design (see page 36), then repeat this process on the other three border lines.

3 Add the outside straight lines to the corner, and the inside triangular shape marked as dotted lines in the top right corner of the illustration. Repeat this on the other three corners to complete the template.

4 Thicken the lines as for the figure-of-eight knotwork (see page 37), taking the cord over and under in turn. Once completed, work around the rest of the design.

5 Tidy up your work, then use a pen to make it permanent. Once dry, erase all of the pencil lines to finish.

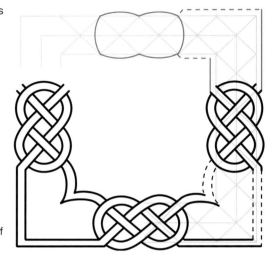

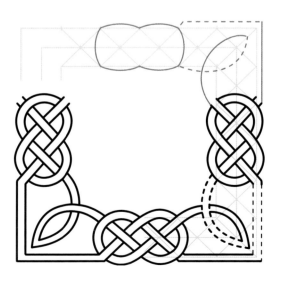

METHOD TWO

Still joining only two lines, this method creates an attractive curved inner shape to the corner.

1 Repeat stages 1 and 2 from method one (see above).

2 Add the outside straight lines to the corner, then the fish/eye-shaped curved lines to the inside corner. You now have your template.

3 Repeat stages 4 and 5 from method one (above) to complete the knotwork frame.

Illuminated B with figure-of-eight corners on a knotwork border

Only two lines are needed to join together the figure-of-eight corners, as shown in this illuminated letter. The dark colours used are viridian green and fluorescent red with lighter shades of pinky reds to highlight.

WAVY CORNERS

METHOD ONE

For wavy line knotwork corners, we bring three lines of the border to join together at the corners. These separate, yet interweaving, lines then follow their own continuous never-ending journey around the border

1 Lightly mark the guidelines with an HB pencil every 2cm (¾in) all the way round, offsetting the marks as shown. Join these marks as in stage 1 on page 38 to create a framework grid on which to work.

2 Fill in the first straight part using steps 1–2 of the waves knotwork design (see page 38), then repeat this process on the other three border lines.

3 Add the new straight lines to the outside of the corner, then draw new curved lines on the inside corner so that they come together as shown by the dotted lines on the top right of the diagram. Next, draw a straight middle line across the corner to join the middle knotworks together.

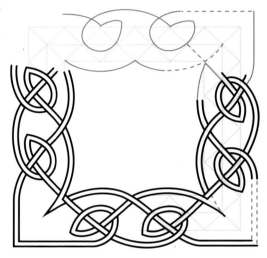

4 Thicken all of the lines of the border, including the corners, as shown on page 39.

5 Do the usual process of tidying up, penning in and, of course, rubbing out all the pencil work.

METHOD TWO

This second method fills the gaps at the corner more fully.

1 Repeat stages 1 and 2 of method one (above).

2 Add new straight lines to the outside of the corner, then add the curved lines to the inside corner to form a fish/eye shape inside. Then add the straight middle line to join the inner knotworkings together.

3 Repeat stages 4 and 5 from method one to complete the continuous three line wavy knotwork border.

Illuminated C with wavy corners on a knotwork border

The wavy knotwork consists of three lines that are brought together in these corners. The darker colours used are deep violet and fluorescent pink. The lighter shades are white mixed together with a touch of the same fluorescent pink.

SEMICIRCULAR CORNERS

METHOD ONE

Creating corners for semicircular knotwork borders are the easiest to do because there is only one line running through the whole design.

1 Lightly mark the centre square with an HB pencil every 2cm (¾in) all the way round, offsetting the marks 1cm (⅜in) from the corners as shown.

2 Start adding the semicircular knotwork template (see page 40) to the borders.

3 Highlight the straight corner lines which you will have already drawn as part of the outer square – these are marked by the dotted lines at the top right on the illustration.

4 Taking the lines over and under one another in turn, thicken your semicircular knotwork thin lines. Continue the process to include the corners. The bottom right-hand corner of the illustration shows this with dotted lines.

5 Tidy your work, then use a pen to make the lines permanent before rubbing out the pencil lines.

METHOD TWO

The first method leaves a gap which can make the piece look sparse. This method adds an additional flourish that echoes the semicircles of the design.

1 Repeat stages 1–3 from method one (above).

2 To make the border look a little more substantial, add an extra curved line at each corner to match the curve of the semicircular knotwork pattern as shown by the marked lines at the top right of the illustration.

3 Repeat stages 4 and 5 of method one to complete the border.

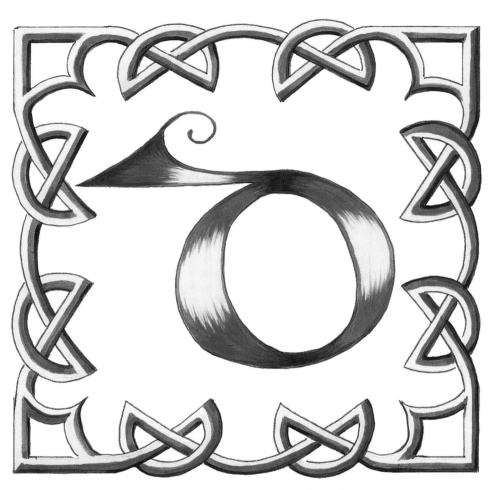

Illuminated D with semicircular corners on a knotwork border

*Although the semicircular knotwork only has one line running through it, I have
added an extra one at the corners to make them look more substantial and solid.
The colours used here are viridian green and fluorescent blue. The highlight hue is
a mixture of white and fluorescent blue.*

COLOURING KNOTWORK

COLOURING WITH PURE LINES

Plain knotwork designs look attractive, but you may wish to enhance your finished piece with colour for decoration and to give the impression it is three-dimensional. The method shown here imagines that there is a light source shining down from above. As a result, the parts of each cord in the knotwork will be lighter in colour at the top near the light source, and darker at the bottom, further away from the light source. Keep this in mind while you work, and remember that the same rule applies even if your knotwork curves or goes round a corner.

1 Paint a pure line of deep violet colour (or appropriate dark tone) on the bottom part of the cords that make up the border to represent the shading away from the light source.

2 Paint the second pure line of colour in the centre of the cords. This is a lighter shade of purple which is made by mixing white paint with a touch of the same deep violet used earlier.

3 Finish off by painting the third pure line of colour on the top part of the cords. This is the highlight and is made by mixing the white paint with a tiny touch of your shade colour.

54

Multicoloured lines

This method of colouring knotwork is very flexible, and can be used in different ways. The steps on this page show how four colours (rather than three, as in the example opposite) have been built up. As long as you work from dark to light tones, you can mix and match colours as you wish. Here I have worked from brown to pink to orange to yellow – the different hues all work well together in the final knotwork (bottom).

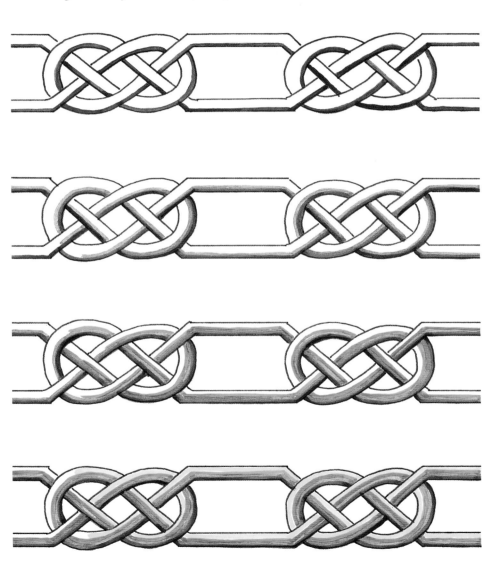

COLOURING WITH FEATHERING

Here I will show you how to turn a flat penned knotwork design into a three-dimensional looking piece of work. I call this feathering because the fine lines at the edges of blocks of colour appear a little like feathers.

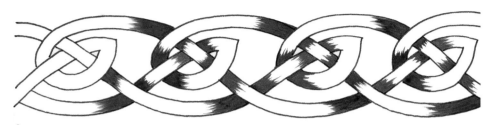

1 Colour the areas of the cords that are emerging from under other cords with your darkest shade, using feathery fine lines at the ends as shown. This will highlight the part of the knotwork that is going over the cord. The hue I use here is an equal mix of ultramarine and phthalocyanine green acrylic paint.

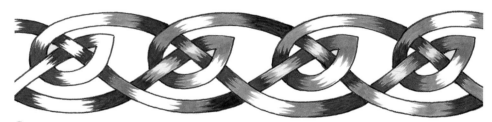

2 Mix white with a little of your darkest shade to make a midtone, and add this colour on the ends of the dark areas, using the same technique.

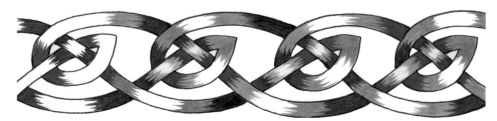

3 Add more white to the mix to make a highlight and extend the colour using the same feathering strokes technique. Add this colour on the ends of the midtone areas as shown, to fill in the areas of the cords that going over the other cords.

Feathering with more tones

*The more tones you use, the more subtle the blending effect will be.
The example below shows how four green tones are built up to create
the three-dimensional effect. Note that you will need to reduce the area
covered by each tone.*

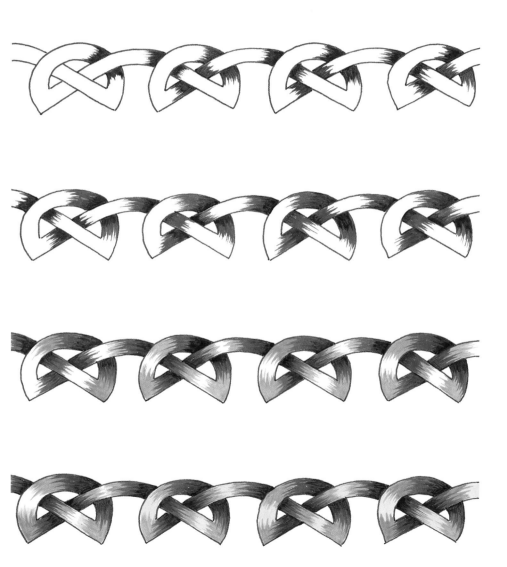

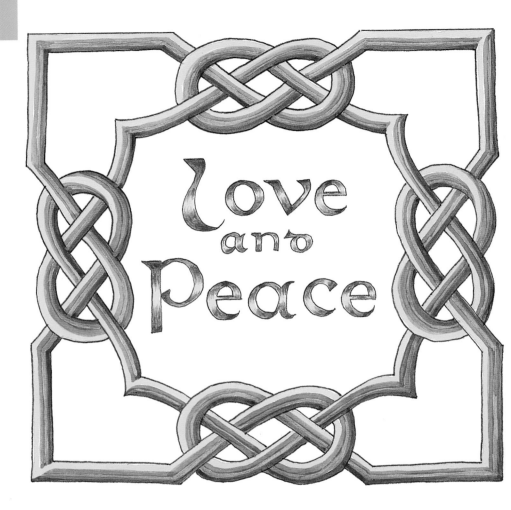

Love and Peace

I have used the pure lines technique for this piece. The shades used are a chocolate brown line, followed by fluorescent pink (with white added to it) then orange for the midtone. The highlight is fluorescent yellow.

These bright colours give a dazzling effect, especially in daylight. I have used the feathering technique for the lettering.

58

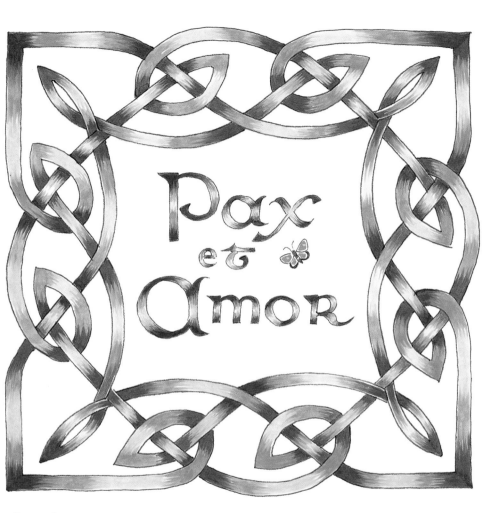

Pax et Amor

I have used the feathering technique for this artwork, a companion piece, written in Latin, for Love *and* Peace *(opposite). The dark shade, applied first, is a mixture of equal parts aquamarine and phthalocyanine green (viridian green is a good alternative) acrylic paint. The midtone and highlight are simply the same mix with progressively more white paint added to tint the colour. I have used the same technique and colours for the lettering.*

EMBELLISHMENTS

The embellishments on the following pages are grouped into different types, and can be used however you wish – as additions to knotworks, flourishes on individual letters or as part of a repeating pattern. Simply follow the steps from left to right to draw and colour each embellishment.

FLORAL EMBELLISHMENTS

This is my favourite part of embellishing calligraphic works, as I love illustrating flowers, especially wildflowers. It is always lovely to give a gift to somebody when a piece is embellished with their favourite flower.

BLUEBELL

SWEET VIOLET

The leaves of sweet violet are heart-shaped. Use different shades of the same colour for the petals.

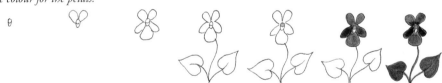

WILD ROSE

I have provided front and side-on versions of the wild rose – using both types in an artwork gives interest and natural variety.

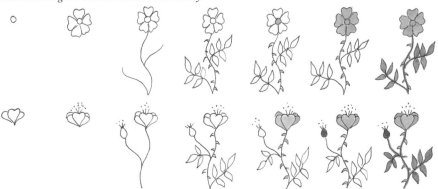

DAFFODIL

Daffodils look quite different from the front and from the side, so both are shown here.
Like the wild roses, try combining both types in the same illustration.

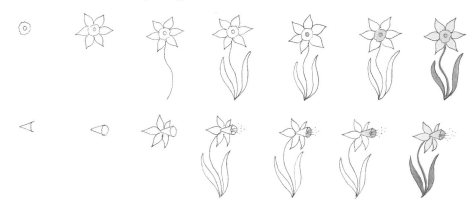

Diamond and Roses

Wild roses and purple emperor butterflies are suitably
beautiful embellishments for this precious gem.

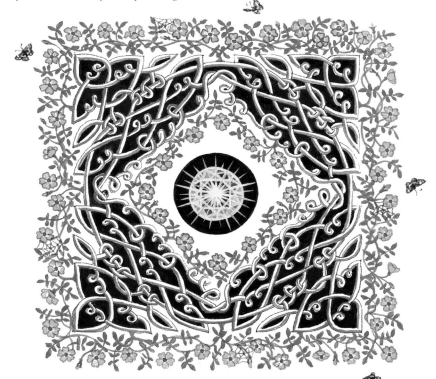

BUTTERCUP

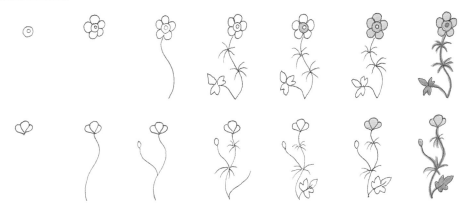

POPPY

The upper version of the poppy is more illustrative, like the mediaeval style seen in Celtic manuscripts, while the lower one is more complex and realistic.

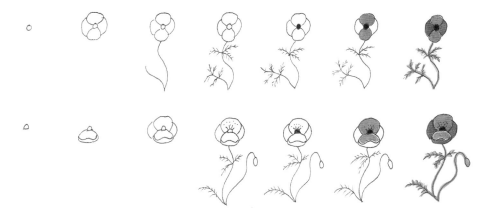

HEATHER

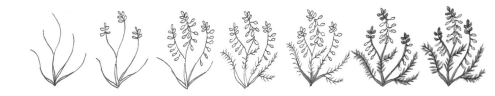

DAISY

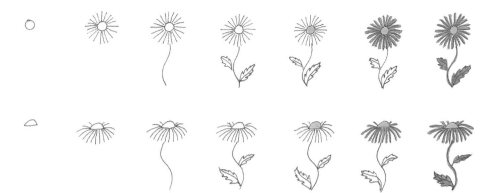

Carnelian and Poppies

Wild poppies and damselflies, that both echo the colour of the gem, adorn this piece.

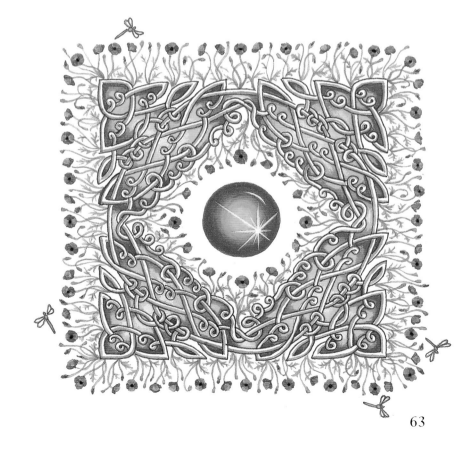

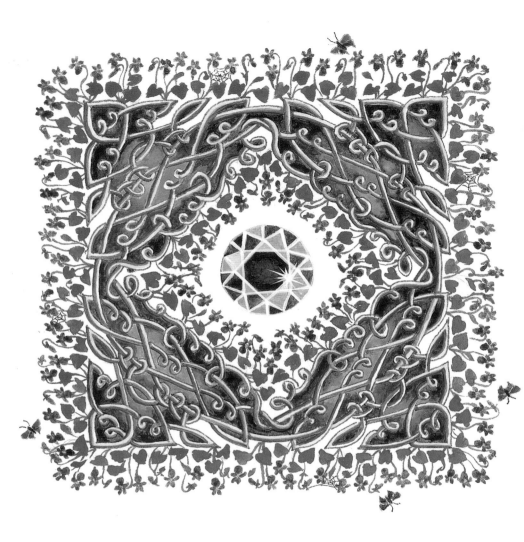

Amethyst and Violets

Like the others in this series of paintings inspired by birth stones, the floral embellishments I have chosen are colour coordinated to match the different gems.

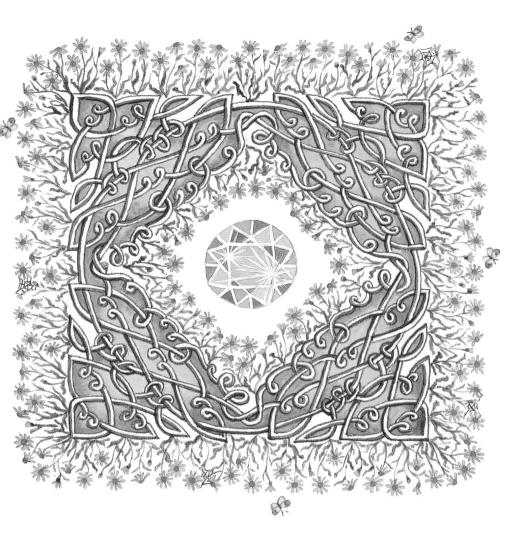

Topaz and Daisies

Yellow daisies and orange tip butterflies are the embellishments used here. All of the pictures in this series use the same knotwork design, which was inspired by a wild vetch flower – its tendrils were just perfect to be in a knotwork. Note how the colours of the gemstone are used to decorate the spaces in the knotwork in each example.

FRUIT EMBELLISHMENTS

Using fruit embellishments in your knotwork and calligraphy
will bring a glorious and rich fruitfulness to your artwork.

APPLES

Paint in the lighter green of the fruits before blending in the red blush.

PEARS

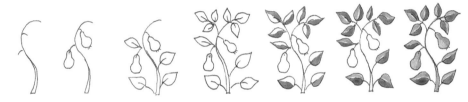

ROWAN (MOUNTAIN ASH) BERRIES

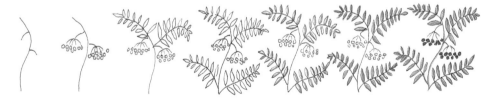

CHERRIES

*When dry, use white acrylic paint to add a crescent-shaped highlight
to the fruit for that extra mouth-watering touch.*

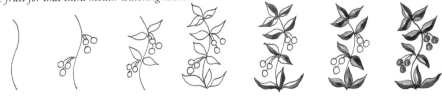

BLACKBERRIES

Do not forget the thorns at the end!

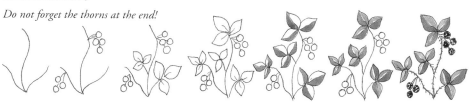

RASPBERRIES

Ruby and Raspberries

I decided to pick raspberries as my fruit of choice for the ruby. One of my favourite insects, the cinnabar moth, is also a great colour match.

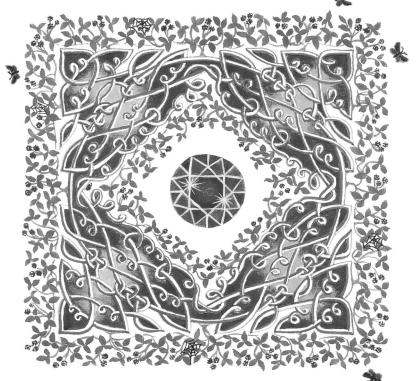

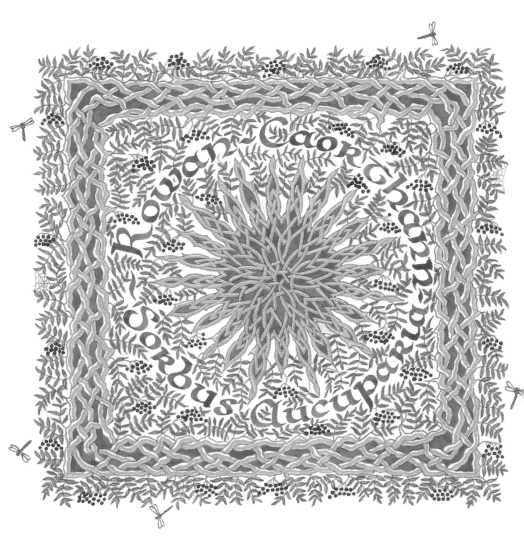

Rowan Tree

The rowan, or mountain ash, is traditionally believed to have mystical powers which protect against witchcraft and enchantment. The calligraphy and knotwork here is embellished with leaves, fruit and large red damselflies.

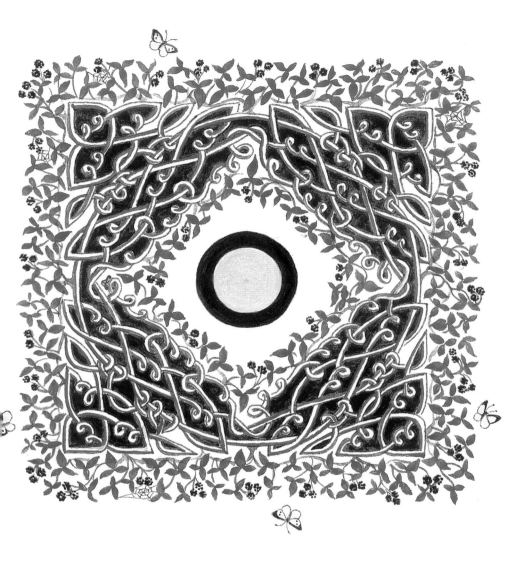

Pearl and Blackberries

For this picture in the birth stone series, I chose blackberries to match the dark background and to emphasise and highlight the pearl. The markings and colourings of large cabbage white butterflies are also perfect for the finishing touches.

FOLIAGE AND LEAF EMBELLISHMENTS

Foliage and leaves are a must-have for that extra traditional touch. They give such feelings of verdant richness with their different decorative shapes, along with that lovely sense of warmth that mother nature brings.

SHAMROCK

A classic Irish motif, the shamrock is made up of heart shapes. Feathered colouring, (see page 56) as used here, works well to suggest their form.

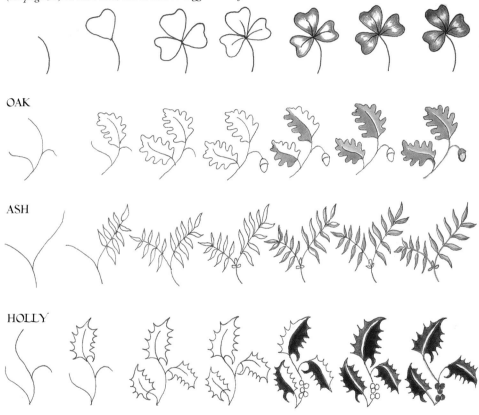

OAK

ASH

HOLLY

GRASS

The feathering technique (see page 56) works well to suggest the shape.

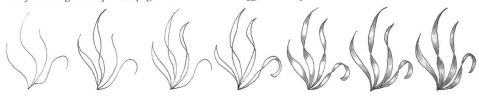

70

IVY

I always find this leaf a bit of a challenge, as some of the leaves have five points while others have just three. Add the fine white veins with white paint once you have coloured the leaves.

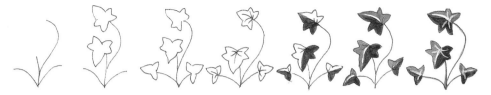

WHITE BRYONY

Another complex embellishment, pay careful attention to the shapes of the leaves before adding the curly fronds.

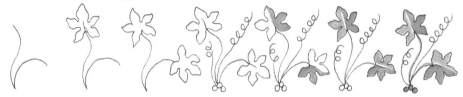

Amulet

This design was inspired by a semicircular knotwork design which can be found at the base of one of the columns in the Book of Kells. *I have joined the two semicircles together to create the inside of the amulet. Shamrocks encircle the central motif for decoration. In turn, these are surrounded by a border of semicircular knotwork.*

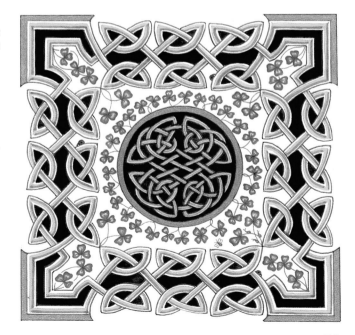

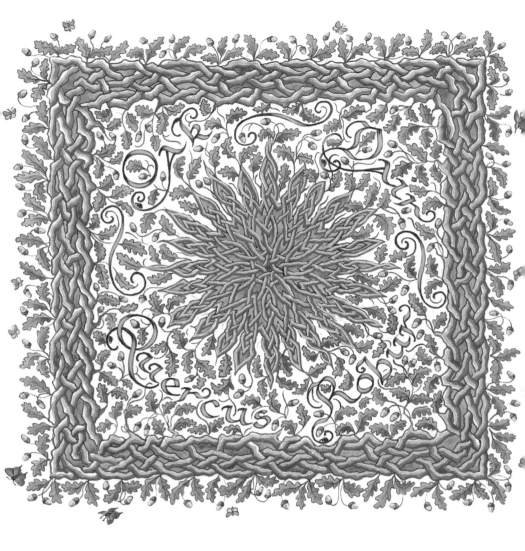

Oak

The mighty oak is revered in many Celtic traditions for its magical powers. This picture, from my birth tree series, is adorned with leaves and acorns. I have also included the green oak moth and the spectacular purple hairstreak butterfly, both of which produce caterpillars that love to devour this beautiful giant.

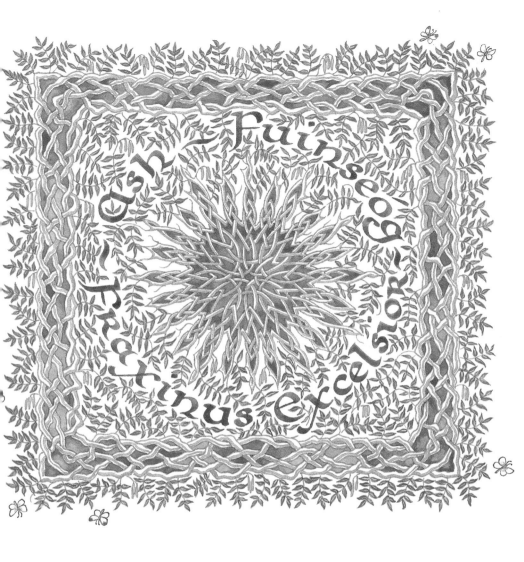

Ash

*The ash, like the oak, is traditionally revered as one of the most
powerful and important trees in Celtic mythology. Here the knotwork is
embellished with the leaves of the ash and wood white butterflies.*

INSECT EMBELLISHMENTS

I always feel that it is all the little extra details that truly make a work of art extra special. This is why I always add insects and similar details at the end of a piece for that final finishing touch. I hope you will too!

BUFF-TAILED BUMBLEBEE

Using brilliant shimmering blue interference medium on the wings will make this bee truly look like it can fly.

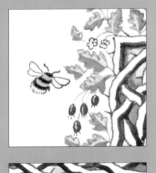 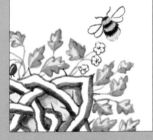

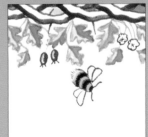 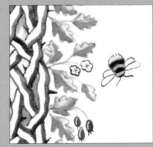

Bee details from Hawthorn

Here is a close-up example of the hawthorn birth tree that shows all the extra little details that I always love to add. It includes the buff-tailed bumblebee, may (hawthorn) flowers and of course the fruit, which are called haws but are also sometimes known as the 'fairy pears'.

You can see the full image on page 7.

74

HOLLY BLUE BUTTERFLY

The stages to build this holly blue butterfly can be adapted to almost any breed. Pay careful attention to the markings and shape of the wings of your chosen species.

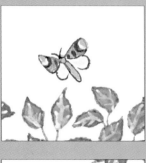 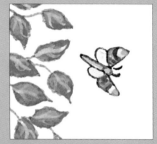

 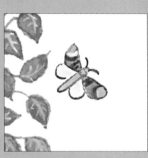

Buff-tip moth details from Birch

Another close-up example. This time I have used a buff-tip moth whose offspring will enjoy eating the birch leaves.

You can of course use any type of insect or butterfly and paint them with any colour and markings you wish, in order to match the colour scheme of your picture. Be adventurous!

You can see the full image on page 27.

TWO-SPOT LADYBIRD

You can, of course, vary the number of spots and colours to produce other species of ladybird.

ZOOMORPHIC MOTIFS

Incorporating animal shapes into your knotwork motifs is a fantastic way of embellishing a piece of work. They are such a joy to do, and you can really play and have fun when doodling the rough preliminary sketches. You can choose anything from the animal kingdom that you wish to use, and motifs can be extended into borders.

FISH

Following the instructions on page 36–37, draw a single figure-of-eight knotwork motif and keep the top and bottom four lines of the knotwork open. Pencil in the new fish and tail outline shapes before adding the smaller details. Once you are happy with your rough sketches, use a very fine drawing pen to make the picture permanent, then rub out your rough pencil marks. I have used the pure lines technique (see pages 54–55) to colour the knotwork and the feathering technique (see pages 56–57) for the fish heads and tails.

Colouring the fish

The dark colour I have chosen is an equal mix of aquamarine and phthalocyanine green. The midtone is a shimmering blue interference colour medium, with a touch of the darker colour added to it. The highlight shade is the same shimmering blue interference medium with just a tiny spot of the dark colour added. If you add motion to your finished piece when holding it up to daylight, these shimmery sea-life colours will bring your fish to life.

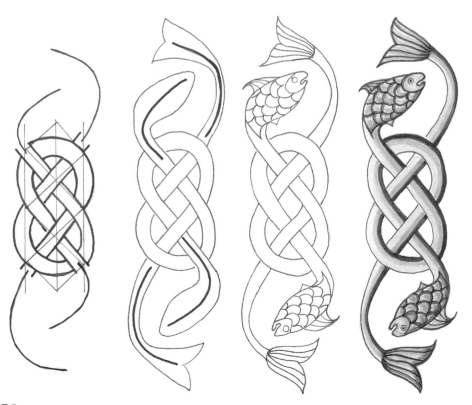

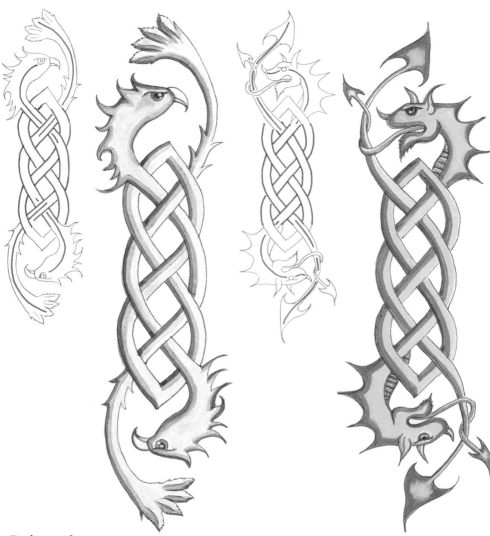

Eagle motif

This eagle motif was built up in a similar way to the fish opposite, using the plaited knotwork design (see pages 34–35) which has four lines at each end. Join two of these lines together to complete the knot, and use the other two for the head and tail feathers. Once made permanent, the piece was coloured using deep violet, grey-brown and silver highlights with the pure lines technique (see pages 54–55).

Dragon motif

This motif uses the fiery Welsh dragon as the theme to decorate a plaited knotwork design. The pure lines technique has been used for colouring, but this time I have chosen red with lighter shades.

TIP
Once you have drawn one end of a design to your satisfaction, trace it to reproduce an identical mirror image at the other end to end up with a perfect picture.

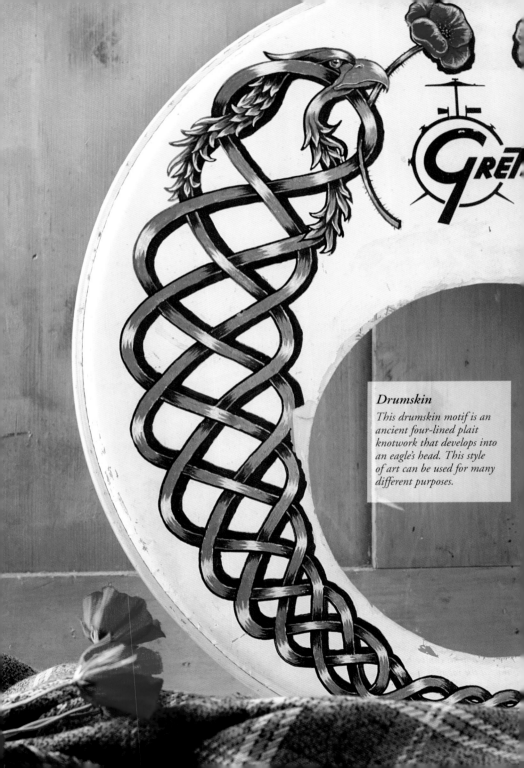

Drumskin

This drumskin motif is an ancient four-lined plait knotwork that develops into an eagle's head. This style of art can be used for many different purposes.

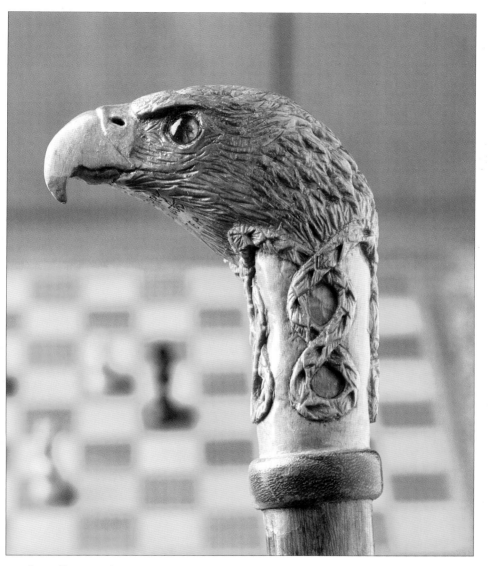

Eagle Walking Stick

This walking stick, hand carved by Len Smith, incorporates a zoomorphic design inspired by my drumskin commission (see opposite). It is a beautiful eagle's head bordered by Celtic knotwork, and is an example of how these embellishments can be used. The eagle eyes actually seem to follow you around the room!

FLORAL MOTIFS

I use a lot of floral motifs in my work, so I had to include them in this book, especially as I am passionate about wild flora and fauna. They are basically the same as the traditional zoomorphic designs, but use flowers to decorate the knotwork instead of animals.

POPPY

Use an HB pencil to draw in the wavy knotwork design (see pages 38–39), leaving the three ends at the top and bottom of the design open. Next, sketch poppy flowers (see page 62) and a seed head above the top part of the knotwork lines and join them into the design with stems, as shown. Extend one of the open ends at the bottom of the knotwork and turn it into a blade of grass (see page 70), then bring together the other two lines to complete the knotwork. Finish the drawing by adding another blade of grass and then the feathery leaves.

Use a fine pen to make your sketch permanent once you are satisfied with your drawing, then erase the rough pencil marks.

Colour in the knotwork stems using the pure lines of colours technique (see page 54), extending the colour into the stems. I used a dark emerald green, a lighter leaf green and fluorescent yellow with a tiny touch of leaf green mixed in for the highlight tone. I have used the same colours with the feathering techniques (see pages 56) for the blades of grass. Paint the top of the seed head a light brown colour and the poppy flowers with a dark cadmium red hue and a lighter cadmium scarlet highlight.

To finish, use deep violet or black to add the delicate details of the poppy centres.

Daffodil

This daffodil was made in the same way as the poppy opposite, but using the two lines of a semicircular knotwork design (see pages 40–41), daffodil flower heads (see page 61) and freehand leaves drawn and coloured using the instructions for grass embellishments (see page 70). The knotwork stems and bud are painted using the pure lines of colour technique (as shown on page 54) while the feathering technique (see page 56) was used for the beautiful trumpeting daffodil flower.

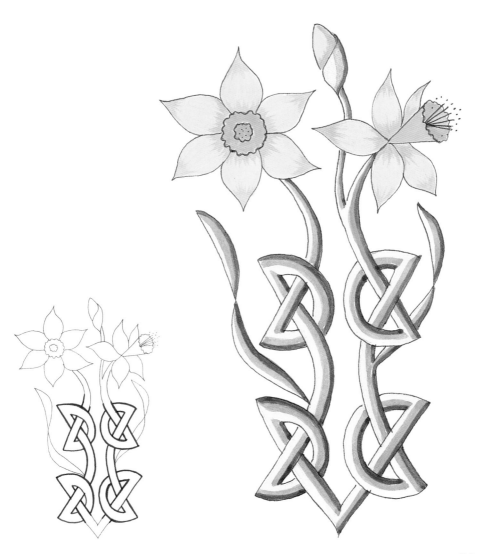

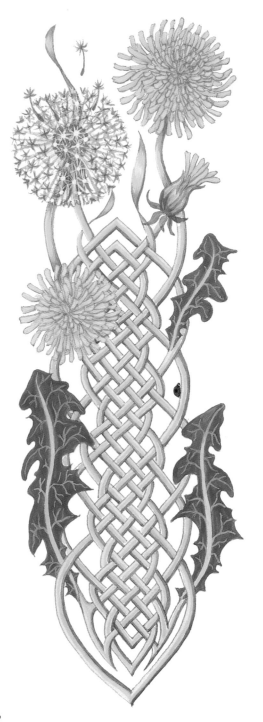

Dandelion

This floral design uses the dandelion flower, clock and leaves to decorate a knotwork design. It is an example from my Fleur Morphic series, inspired by the Victorian love of flowers, which I use for bookmark purposes.

Spear Thistle

The magnificent spear thistle uses a spiky, jagged knotwork here, to give due respect to this great emblem of Scotland. The black fly embellishments seemed to move about as I was working away at my easel!

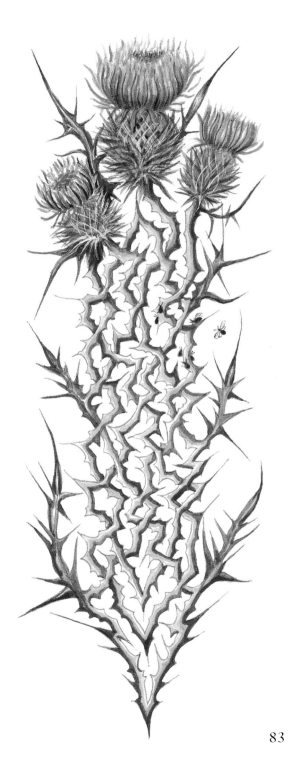

83

BLESS THIS HOME

I have designed this project for the simplicity of its words and design, and also for its traditional and heartfelt warmth. These cherished sentiments will never be out of fashion. I hope you have fun and enjoy the project as much as I have.

YOU WILL NEED

Thick cartridge paper, 210mm x 297mm (8¼ x 11¾in)

Felt-tip pen with a 2mm (⅟16in) nib and permanent black archival quality ink

0.1mm (⅟32in) fineliner and 0.05mm (⅟64in) fineliner

Brushes: size 0 round, size 00 round, size 000 round

Acrylic paints: burnt umber, deep violet, ultramarine blue, titanium white, cadmium scarlet, cadmium yellow deep, fluorescent pink, process magenta, lemon yellow, fluorescent blue, leaf green

Old mixing brush, china plate or mixing palette

Rough paper

HB pencil and putty eraser

Ruler

1 Practise the calligraphy on rough paper, ruling the lines as described on pages 17–19. Decide how you are going to split up the text into lines. I have decided to have 'Bless' on the first line, and 'This Home' on a separate line.

2 Make a rough sketch of how you want the finished piece to look. I have placed the text slightly above centre, with floral decorations beneath, and surrounded it all with a four line plaited knotwork border (see pages 34–35).

3 Rule up a sheet of rough paper following the instructions on pages 18–19. Using a 2mm (⅟16mm) nib, the measurements of the 1:2:5:2 ratio are 2, 4, 10 and 4mm (⅟16, ⅛, ⅜ and ⅛in); and the space between the two lines of text will be 10mm (⅜in). Write out the text using the instructions on pages 22–27.

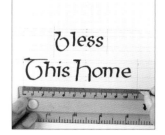

4 Measure and note down the length of each line. With this size nib, 'Bless' should be approximately 50mm (2in), and 'This Home' approximately 110mm (4⅜in).

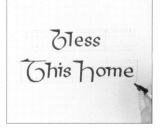

5 Following the instructions on page 19 for placing the text centrally, draw your text guidelines on to the thick cartridge paper, with the top of the text area starting 70mm (2¾in) from the top edge. Using a permanent black pen with a 2mm (⅟16in) nib, write in the lines of your calligraphy.

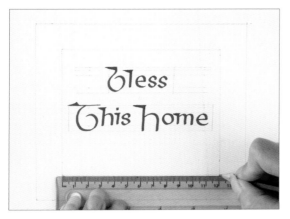

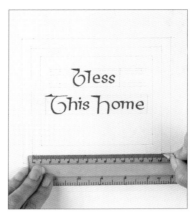

6 Using the HB pencil and a ruler, mark in a rectangle measuring 160 x 140mm (6¼ x 5½in), starting 35mm (1⅜in) from the top and 70mm (2¾in) from the left edge of the paper. This will be the outer border. Mark in a 120 x 100mm (5½ x 4in) rectangle, starting 55mm (2⅛in) from the top and 90mm (3½in) from the left of the paper. This will be the inner border.

7 Mark in a rectangle measuring 140 x 120mm (5½ x 4¾in) between the inner and outer borders, to act as a guideline for your knotwork lines and corners. Start 45mm (1¾in) from the top and 80mm (3⅛in) from the left.

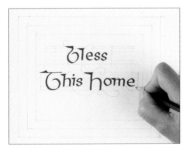

8 Pencil in the flourishes with the HB pencil, being sure to leave a small gap between the flourishes and inner border.

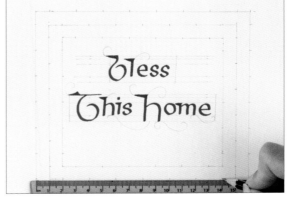

9 Starting 10mm (⅜in) in from each corner, use a ruler and HB pencil to make marks every 20mm (¾in) as shown on the outer border, then make marks every 20mm (¾in) on the inner border and knotwork guideline in the same way, again starting 10mm (⅜in) in from each corner.

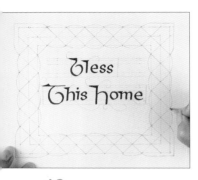

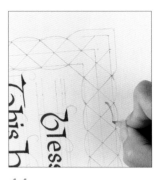

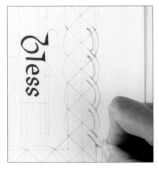

10 Follow the marks on each border to create a grid using a pencil and ruler. Working freehand, develop the border by connecting the marks with curved lines.

11 Choose a starting point for the knotwork border. I have chosen to start on the top side. Draw a curved line parallel to one of the outer curved lines as shown. The important thing is for the knotwork to go alternately over and under the grid lines.

12 Using the previous line as a reference, draw in another curved line, making sure to keep the sequence of going over and under. Continue to the end of the row. Notice how this then flows straight into the corner.

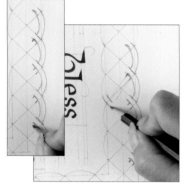

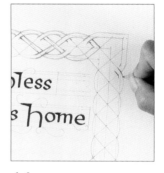

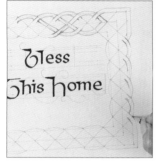

13 Go back and give yourself some guidelines, extending the lines where they go under (see inset). Lightly extend the guidelines of the first part. Where these cross the inner crossover of the grid, they will go over another set of lines, so as you reach the inner border, they need to go under. With this in mind, draw in a curved line parallel to one of the inner curved lines as shown in the main picture.

14 Continue to the end of the row, and draw the final line up to the point shown, then connect the ends of the inner and outer rows into a point. Return to the inner parts and fill them in, starting with the overs and then the unders, up to the corner as shown.

15 Follow the corner round and begin to fill in the side as before. As the corner starts with an over (the end of the previous row), it needs to go under here. Start with some guidelines as shown.

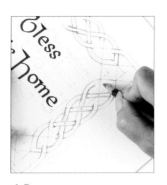 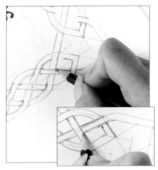 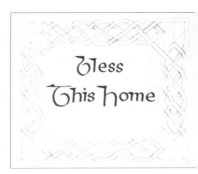

16 Build up the knotwork on the right-hand side, following the instructions for steps 11–15. Work back up and fill in the inner parts. On the inner upper right-hand corner, leave guidelines as shown.

17 With both sides in place, you can now draw the long part across the whole corner, working carefully under and over in turn. You can now complete this corner by going back and filling in the last under as shown (see inset).

18 As you work all the way round the rest of the knotwork border, the final part will connect to the first part naturally.

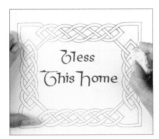 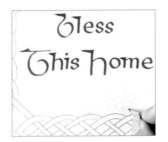 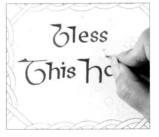

19 Carefully work over the knotwork lines using a 0.1mm (1/32in) black fineliner. Use this opportunity to create clean lines from the rougher pencil work and to make sure the cord of the knotwork is even in thickness all the way around. Once dry, use a putty eraser to remove all of the pencil lines except for the flourishes on the letters.

20 Use an HB pencil to draw small circles above the central part of the lower border. Connect the circles to the knotwork with fine stems, then add foliage and a few rosehips with leaf shapes on the end of stems.

21 Add some butterflies above and around the calligraphy. Draw a little dome on one of the flourishes, then add a little dark area at the front to make a ladybird. Add some more across the writing.

TIP
Feel free to adjust the flourishes to fit around your flowers and foliage as you build them up.

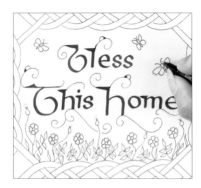 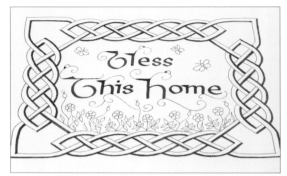

22 Draw a small circle in the middle of each flower, then add five little heart shapes within the flower, with the points touching the circle. This completes the pencil work. Work over the decoration with a 0.05mm (⅟₆₄in) black pen.

23 Use the putty eraser to remove all of the pencil work, then use an old mixing brush to mix burnt umber with a little deep violet, ultramarine blue and titanium white to make a chocolate brown paint. Using a size 0 round brush, paint in the shaded areas of the knotwork cord. The light source is at the top left, so paint the lower right third of each section of the cord.

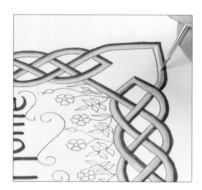 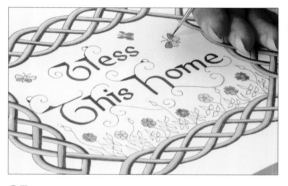

24 Once complete, paint in the mid-toned parts of the knotwork using diluted cadmium scarlet, still using the size 0 round brush. Allow to dry and then use a size 00 round brush and diluted cadmium yellow deep to paint the highlighted parts of the knotwork. Work slightly over the red area, to create a warm transition.

25 Still using the size 00 brush, paint in the centres of the flowers with a less dilute mix of cadmium yellow deep. Next, use a mix of fluorescent pink and process magenta to paint in some of the flowers and one of the butterflies. Paint in the yellow flowers and wings of some of the butterflies with lemon yellow, and use fluorescent blue to paint in the remaining flowers and butterfly wings.

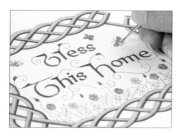

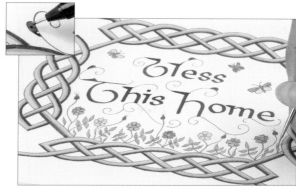

26 Paint in the rosehips and bodies of the ladybirds using cadmium scarlet, then paint the bodies of the butterflies with a mix of burnt umber and titanium white.

27 Use the tip of the size 00 brush to add a touch of titanium white to the head of each ladybird, then use a 0.1mm (1/32in) permanent black fineliner to add a dot to each body (see inset). Finally, use the size 000 brush to paint in the leaves and stems using a mix of leaf green and a little cadmium yellow deep.

The finished piece.

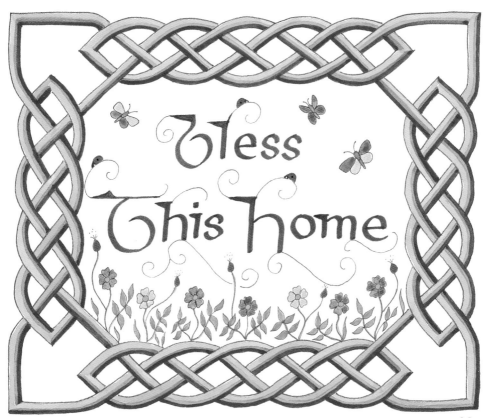

ST PATRICK'S DAY

The book had to end with a celebration piece for one of my favourite days of the year, Saint Patrick's Day. A motif of two entwining snakes echoes the story of Saint Patrick, and the words, in both Irish Gaelic and English are surrounded by a sprinkling of shamrocks. At the very end, do remember to add the tiny four-leaved clover – just for the *craic*!

YOU WILL NEED

Thick cartridge paper, 210mm x 297mm (8¼ x 11¾in)

Felt-tip pen with a 2mm (⅟₁₆in) nib and permanent black archival quality ink

0.1mm (⅟₃₂in) fineliner and 0.05mm (⅟₆₄in) fineliner

Brushes: size 0 round

Emerald green ink

Fine gold marker pen

Old mixing brush, china plate or mixing palette

Rough paper

HB pencil and putty eraser

Ruler

lá F Féhile Paoraig
lá Fhéilé a lá Fhéile la
Paoraíz a Paoraíz a
St Patrick's Oay CO
O Oay la Fheile Oay
Páoraiz ˢSt Patrick's

1 Practise the calligraphy on rough paper, ruling the lines as described on pages 17–19. Decide how you are going to split up the text into lines. I have decided to have 'Lá Fhéile' on the first line, 'Padraig' on the second, and then a large space for a motif before 'St Patrick's' on the third line and 'Day' on the fourth.

2 Make a rough sketch of how you want the finished piece to look. I have chosen a single figure-of-eight knotwork design (see page 36–37) for the body of the snake motif, and run the text around this; before decorating the piece with shamrock embellishments.

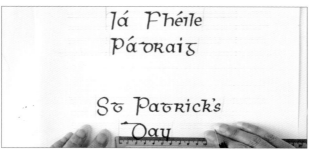

3 Rule up a sheet of rough paper following the instructions on page 19. Using a 2mm (⅟₁₆in) nib, the measurements of the 1:2:5:2 ratio are 2, 4, 10 and 4mm (⅟₁₆, ⅛, ⅜ and ⅛in). The space between the first and second lines will be 10mm (⅜in), as will the space between the third and fourth. Leave a 50mm (2in) gap between the second and third lines – this is the space for the knotwork motif. Write out the text using the instructions on pages 22–27.

TIP

If you look closely you will see the 50mm (2in) gap is split into three sections – 15, 20 and 15mm (⅝, ¾ and ⅝in). This is because I have included the text spacing – 10mm (⅜in) above and below the motif, plus a little extra for the knotwork.

The motif itself will fit in the 20mm (¾in) central area, which is equal in size to the text line – 2+4+10+4mm (⅟₁₆, ⅛, ⅜ and ⅛in) – and I have given an additional 5mm (⅝in) space on either side for the width of the knotwork on the motif.

4 Measure and note down the length of each line. With a 2mm ($\frac{1}{16}$ in) nib, 'Lá Fhéile' should be approximately 110mm (4$\frac{3}{8}$in); 'Padraig' approximately 100mm (4in); 'St Patrick's' approximately 135mm (5$\frac{3}{8}$in); and 'Day' approximately 60mm (2$\frac{3}{8}$in). Following the instructions on page 19 for placing the text centrally, draw your text guidelines on to the thick cartridge paper, with the top of the text area starting 30mm (1$\frac{1}{8}$in) from the top edge. Make an extra guideline on the final line, 5mm ($\frac{3}{16}$in) in from the leftmost guide. This is where the 'D' will start, while the leftmost guide itself is where the flourish on it will finish.

5 Using the permanent black felt tip pen with a 2mm ($\frac{1}{16}$in) nib, write in the lines of calligraphy, remembering to leave space for the motif.

Já Fhéile
Pá-oraig

St Patrick's
Day

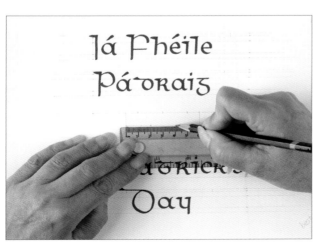

6 The motif will be 60mm (2$\frac{3}{8}$in) across, so centralise this following the instructions on page 19. Use an HB pencil to draw guidelines down the sides of the area, then make marks 10mm ($\frac{3}{8}$in), 30mm (1$\frac{1}{8}$in) and 50mm (2in) in from the left guideline on the top line. Make marks 20mm ($\frac{3}{4}$in) and 40mm (1$\frac{1}{2}$in) in from the left guideline on the middle line.

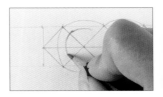

7 Make marks 10mm (⅜in), 30mm (1⅛in) and 50mm (2in) in from the left guideline on the bottom line of the motif, then join up the marks on the motif into a mesh of diagonal lines using the HB pencil and ruler.

8 Join up the marks with curved lines as shown.

9 Pick a starting point (I am starting at the top left-hand side) and draw in an arc parallel to the arc outside as shown. Use the grid to help you determine which parts are going over and which are under.

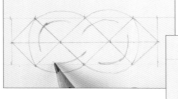

10 Use the earlier marks to help you work round the motif, alternating between overs and unders.

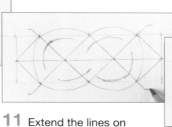

11 Extend the lines on the corners of the grid as shown.

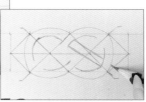

12 Draw the straight line across to the corner mark, taking the cord under, over and under again as shown. Extend the pencil lines slightly past the edge of the motif.

13 Repeat for the other straight lines. The mesh of the knotwork will become clearer as you fill in the lines.

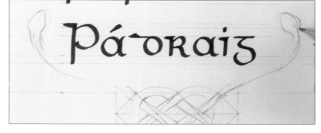

14 Use an HB pencil to sketch in the snakes' heads, and a guideline from the heads to the knotwork to give you an idea of where they will sit. Adjust and redraw with a putty eraser and HB pencil until you are happy.

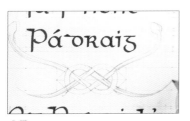

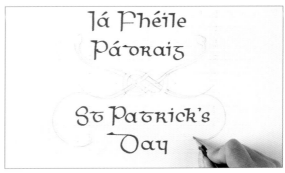

15 Develop the snakes' necks, ensuring that they fit neatly into the knotwork, then draw in their tails, connecting them to the lower part of the knotwork.

16 Use the HB pencil to draw long curlicues, using them to fill space and surround the calligraphy.

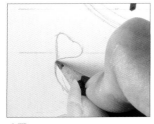

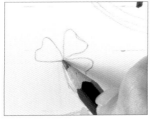

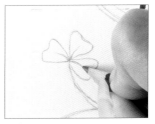

17 To draw a shamrock, draw a short stem with a heart shape on the end.

18 Next, add two more hearts, with the points aiming towards the end of the other heart shape.

19 Finally, add a small line in the middle of each heart shape as a vein.

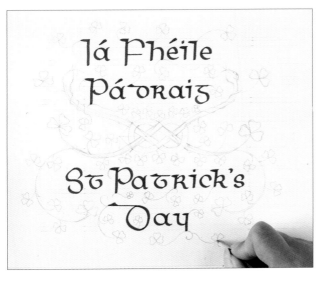

20 Add flourishes to the letters and decorate the whole picture with shamrocks. I have left the veins off the shamrocks, as I will add these later after colouring them.

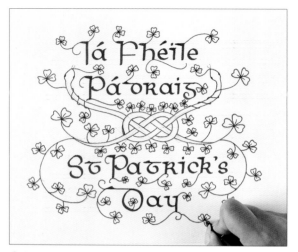

22 Use a putty eraser to remove the rough pencil work, then paint the snakes with emerald green ink using a size 0 brush.

21 Use a 0.05mm (⅟₆₄in) permanent black fineliner to pen in the snakes' tongues, then swap to a 0.1mm (¼in) permanent black fineliner and overlay the pencil work, including the fine veins on the shamrocks.

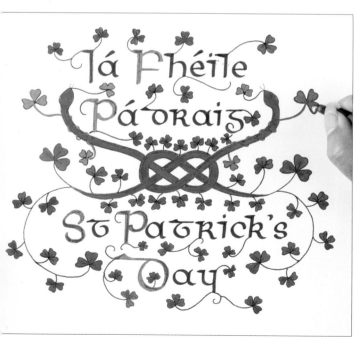

23 Using a fine gold marker, colour the initial letter of each word and add some fine detail to the snakes as shown. Allow to dry thoroughly before painting the shamrocks with emerald green ink and a size 0 brush. Leave the gold-stemmed ones clean; you may like to mark these lightly with a pencil to ensure you do not overpaint them. Allow the green ink to dry, then use the fine gold marker to fill in the gold-stemmed shamrocks.

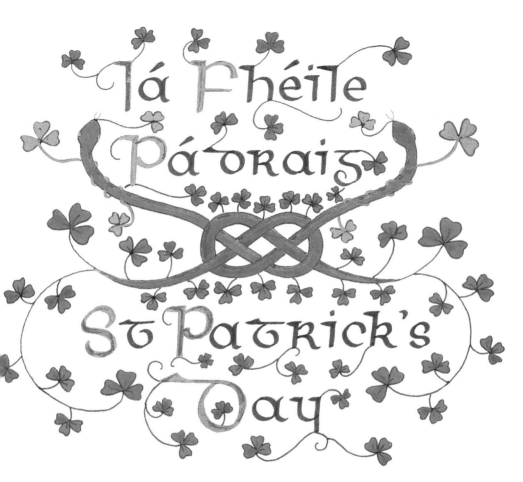

The finished piece.

INDEX